Retro Nudes Adult Stress Calming
Colouring Book
Volume II
By Michael G Quain

First Published 2016 by M.G.Q Publishing

Copyright 2016 by MGQ

All rights reserved. No part of artwork may be reproduced or transmitted, in any form by any means, without permission of the publishers or artist.

Retro Nudes Adult Stress Calming Colouring Book
Volume II
By Michael G Quain

Introduction

My name is Michael G Quain and welcome to Volume II.of my Retro Nude Colouring book series.I have been drawing and colouring nudes for years. With the coming of the internet I suddenly had access to many nudes from the past and it is these I like to draw the most.

The sketches for colouring are not perfect, that is for you to make them look good. Each drawing has the original photograph next to it so you can recreate the photograph in pencil and or charcoal or how ever you want. You can draw or shade in the missing lines. Use the photographs as a reference, but you are free to do what you want to do with the drawings. The front cover of this book is art work I did from an old black and white photograph. Some other examples of my art work are in the pages of this book as examples of what can be done, but more sketches have been added for colouring than in Volume I.

See if you can spot my sexy drawings of Doris Day and Elizabeth Taylor. Doris Day never posed in lingerie so I had to draw her head onto a sexy body. Not easy to do.

Have fun.

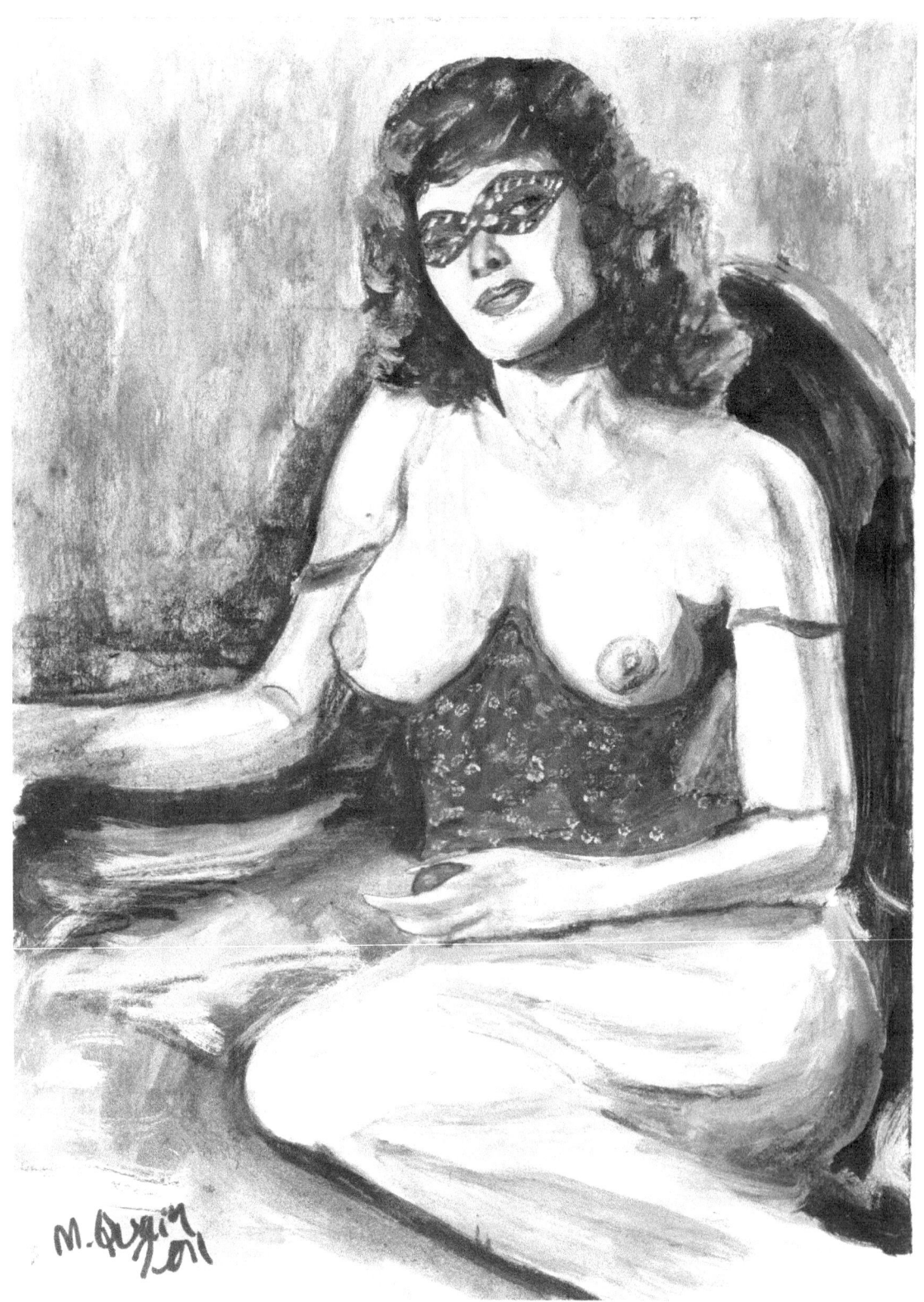

From Photograph to Art

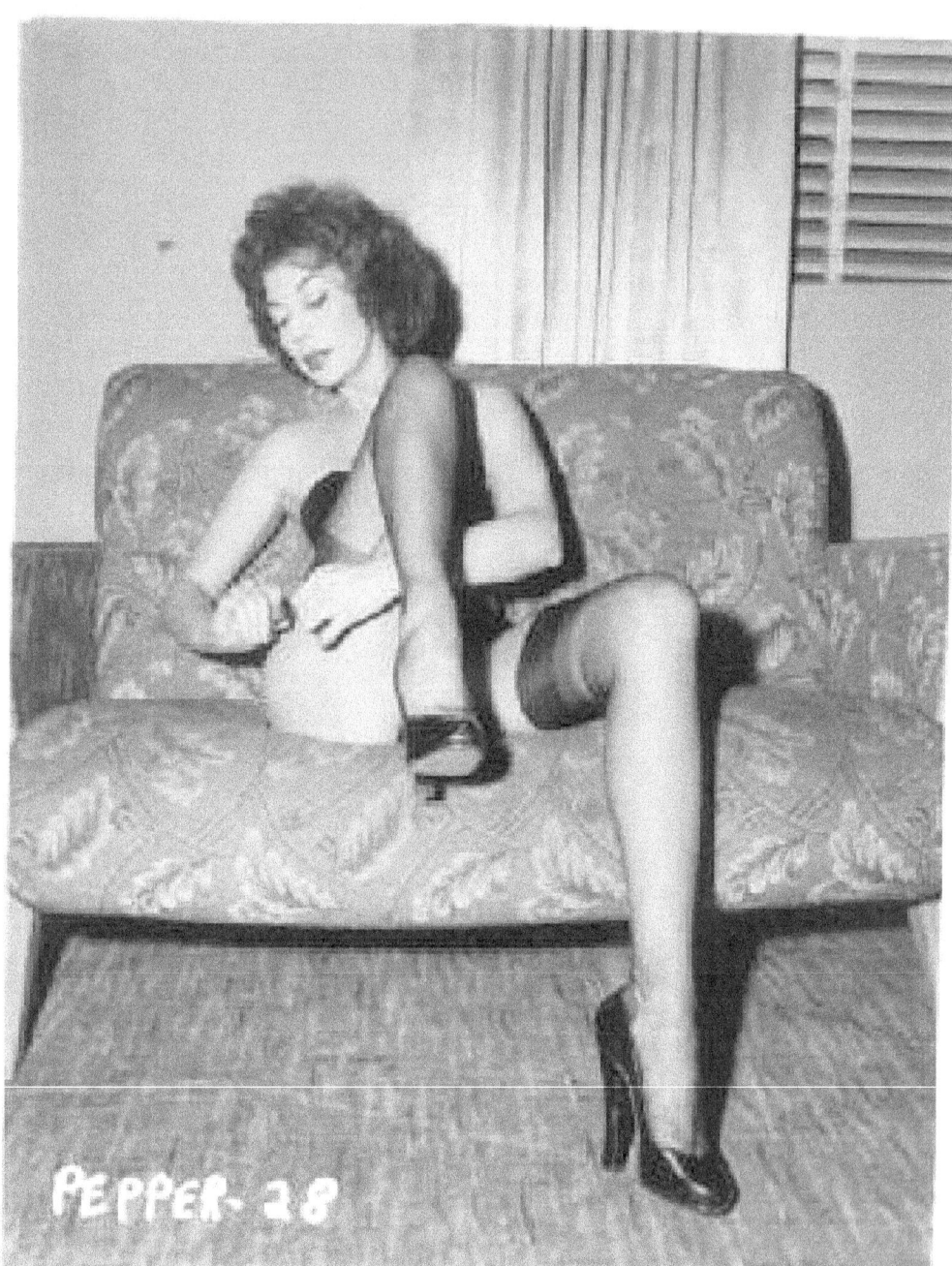

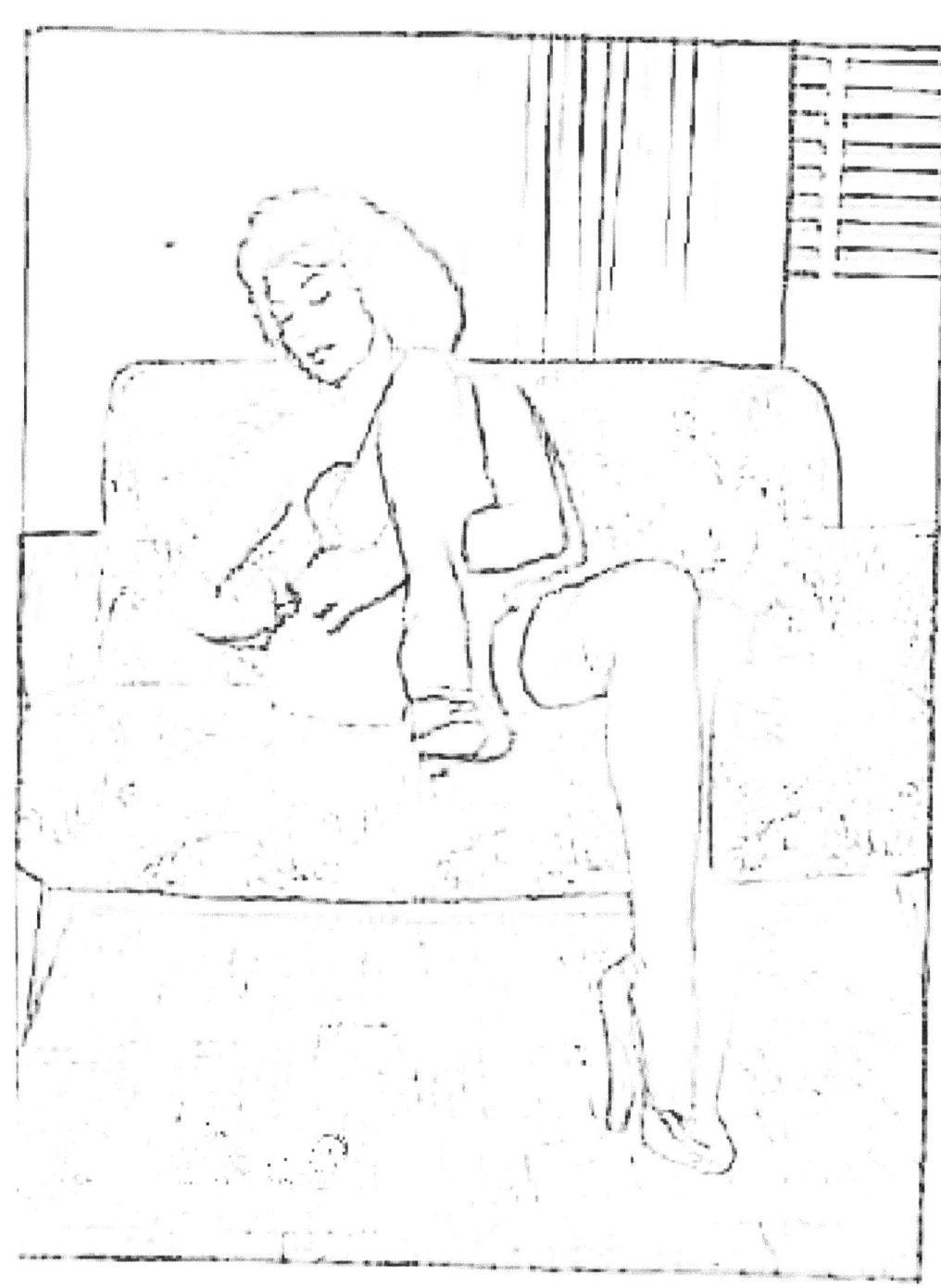

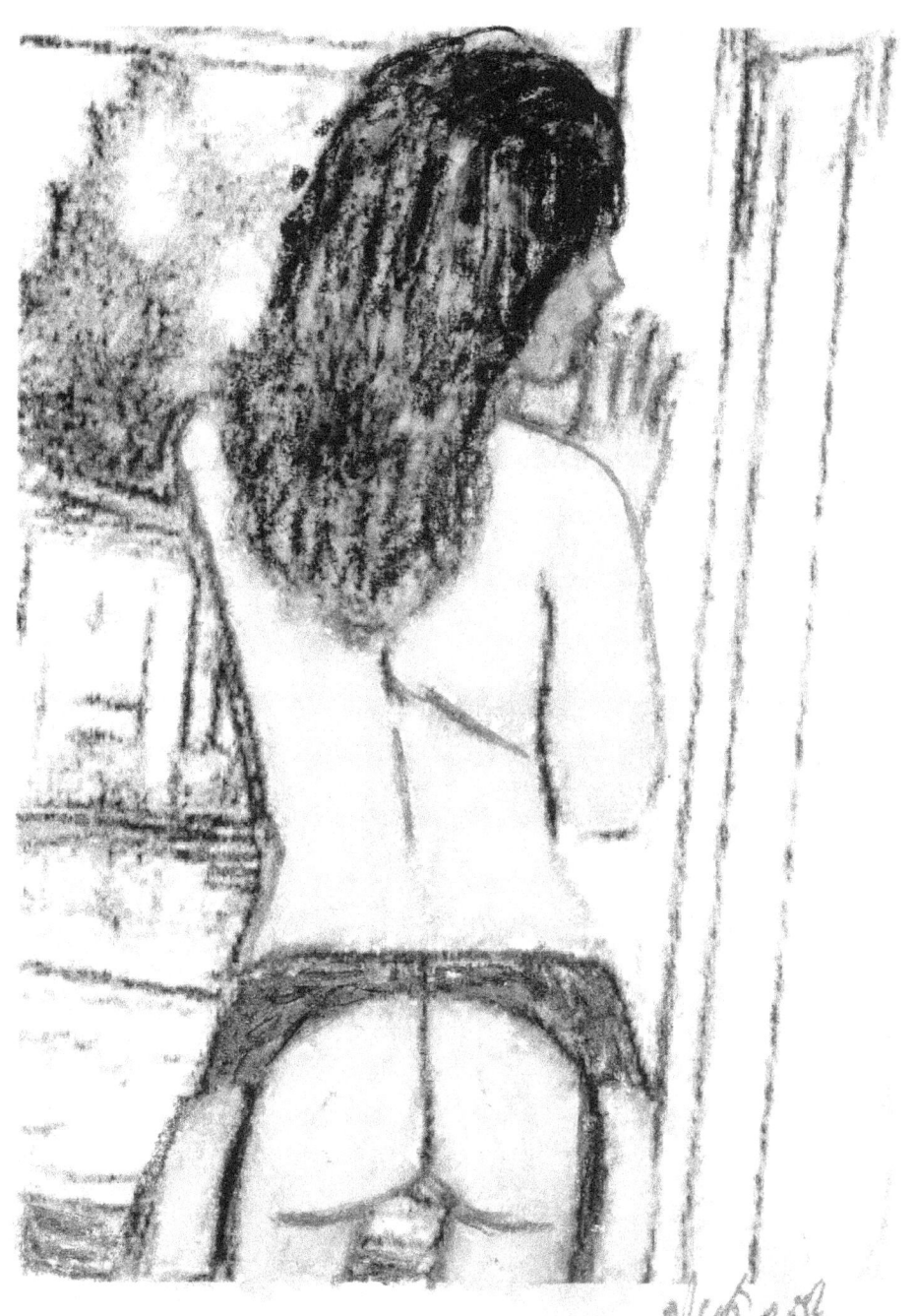

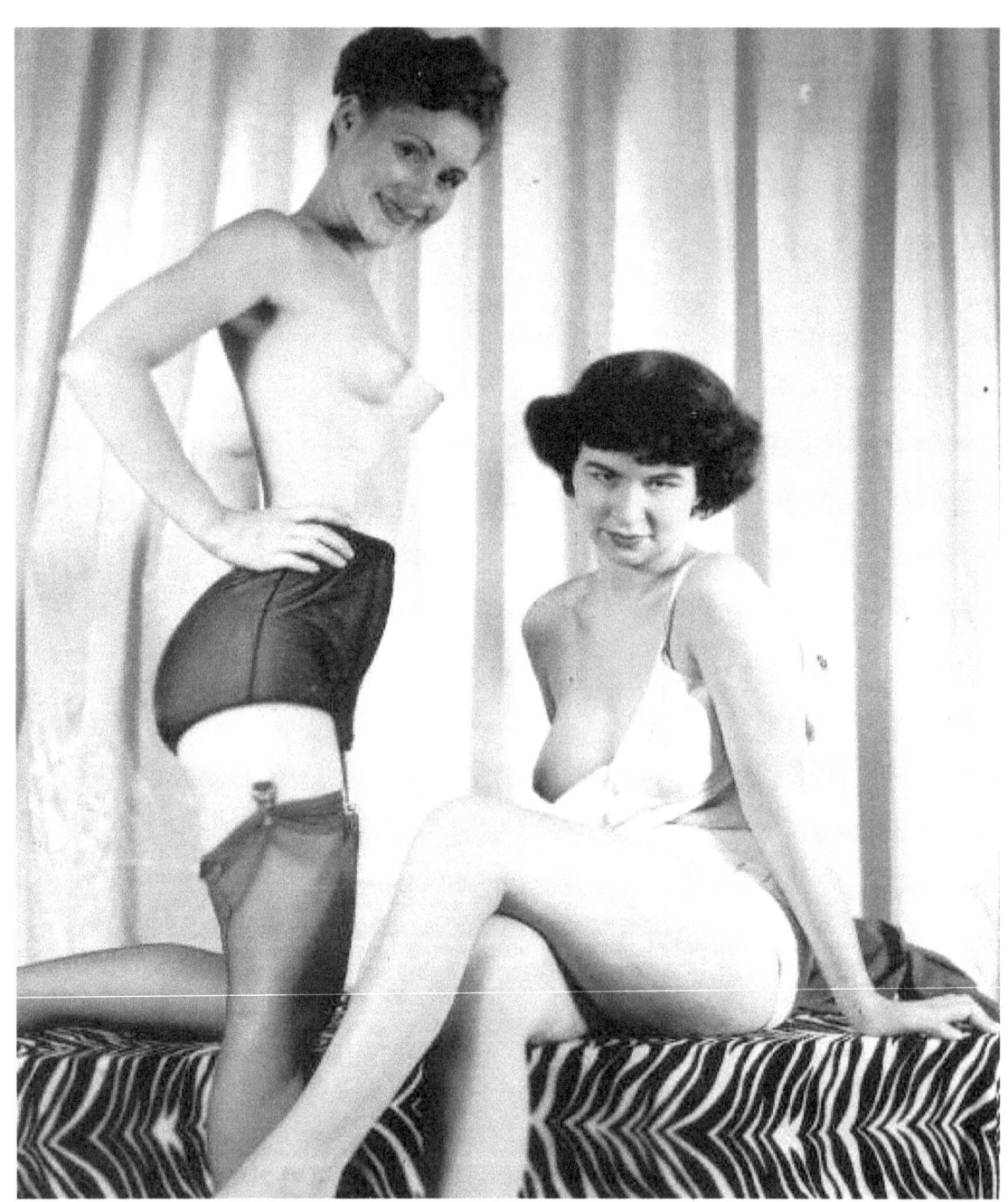

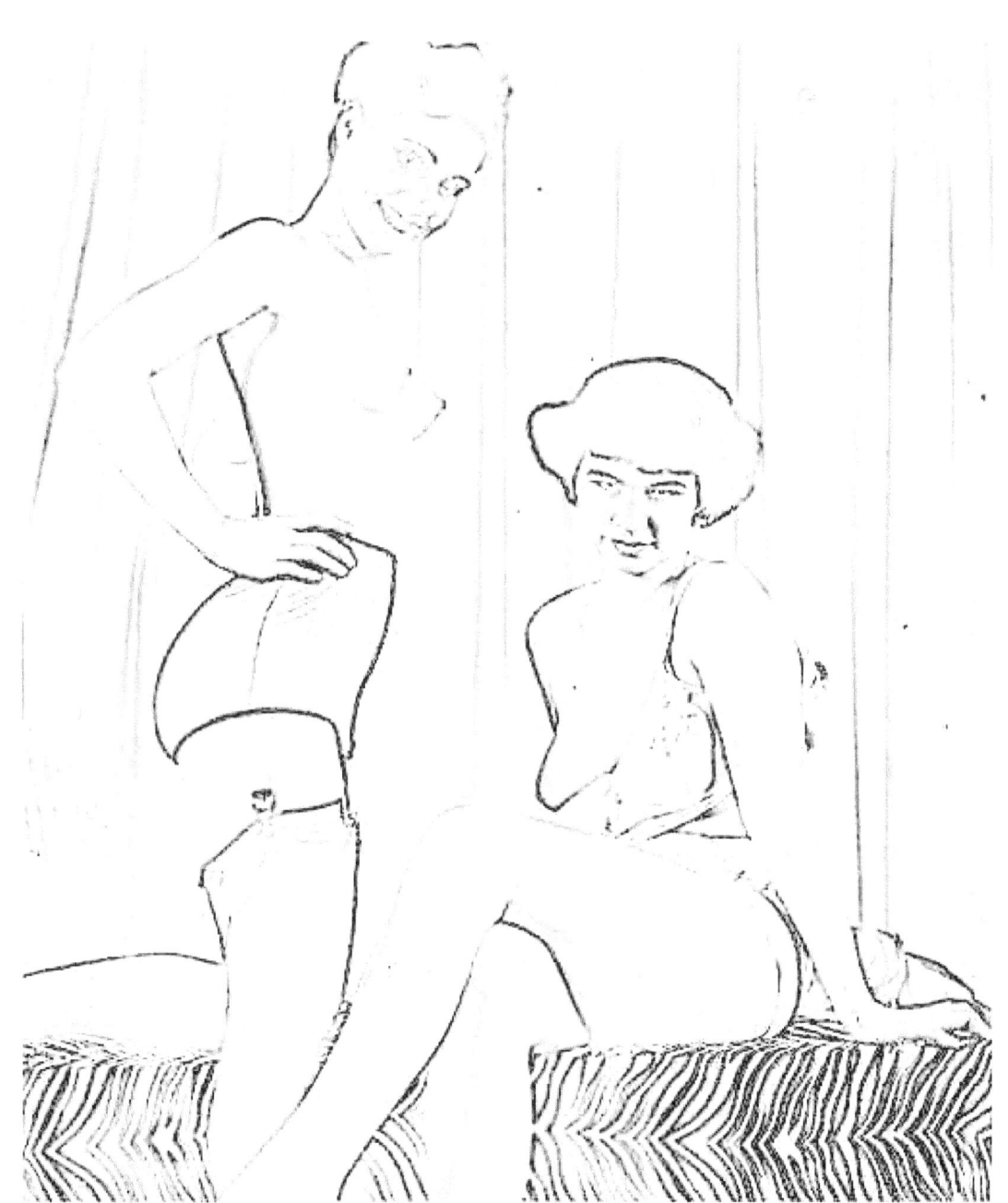

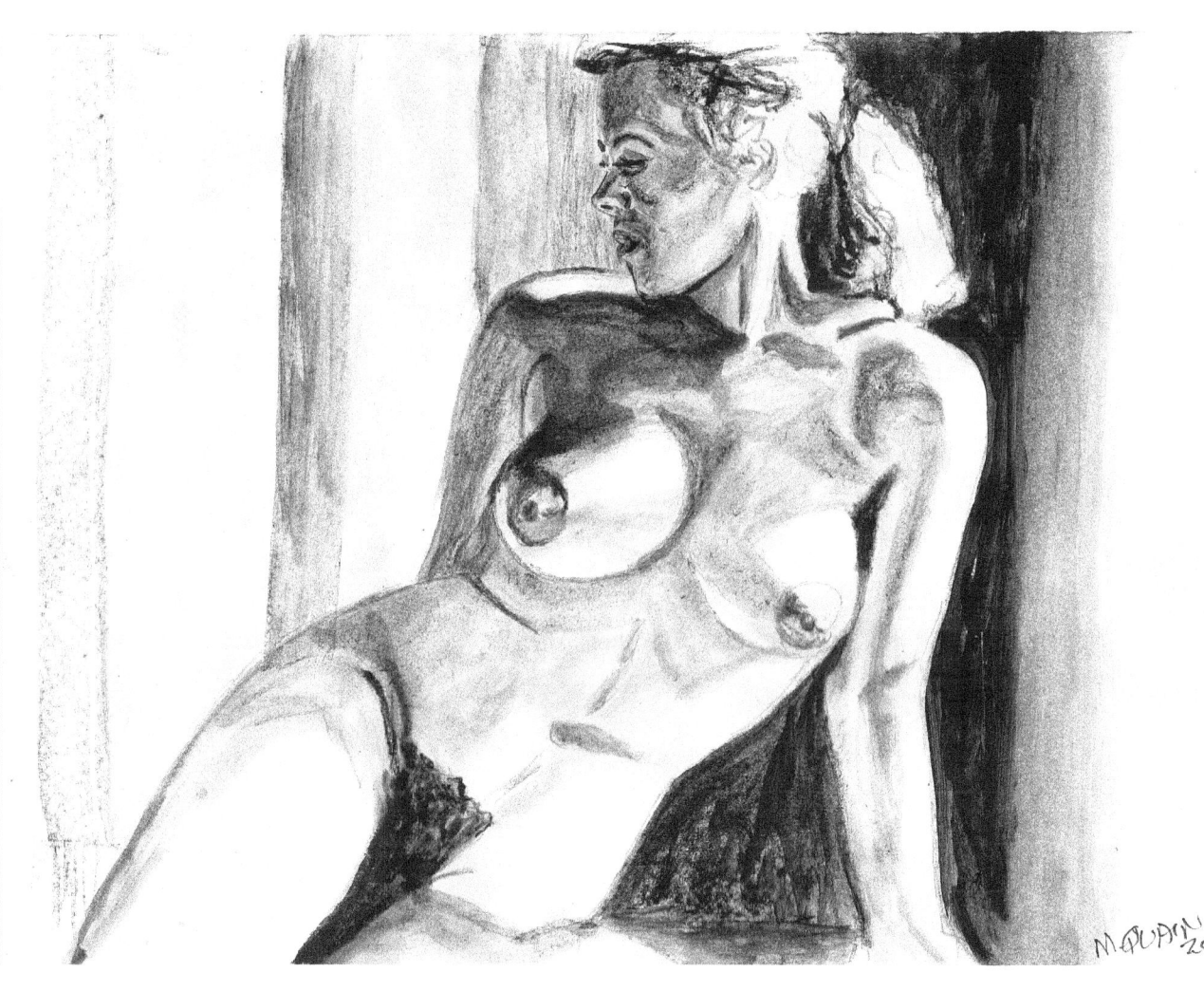

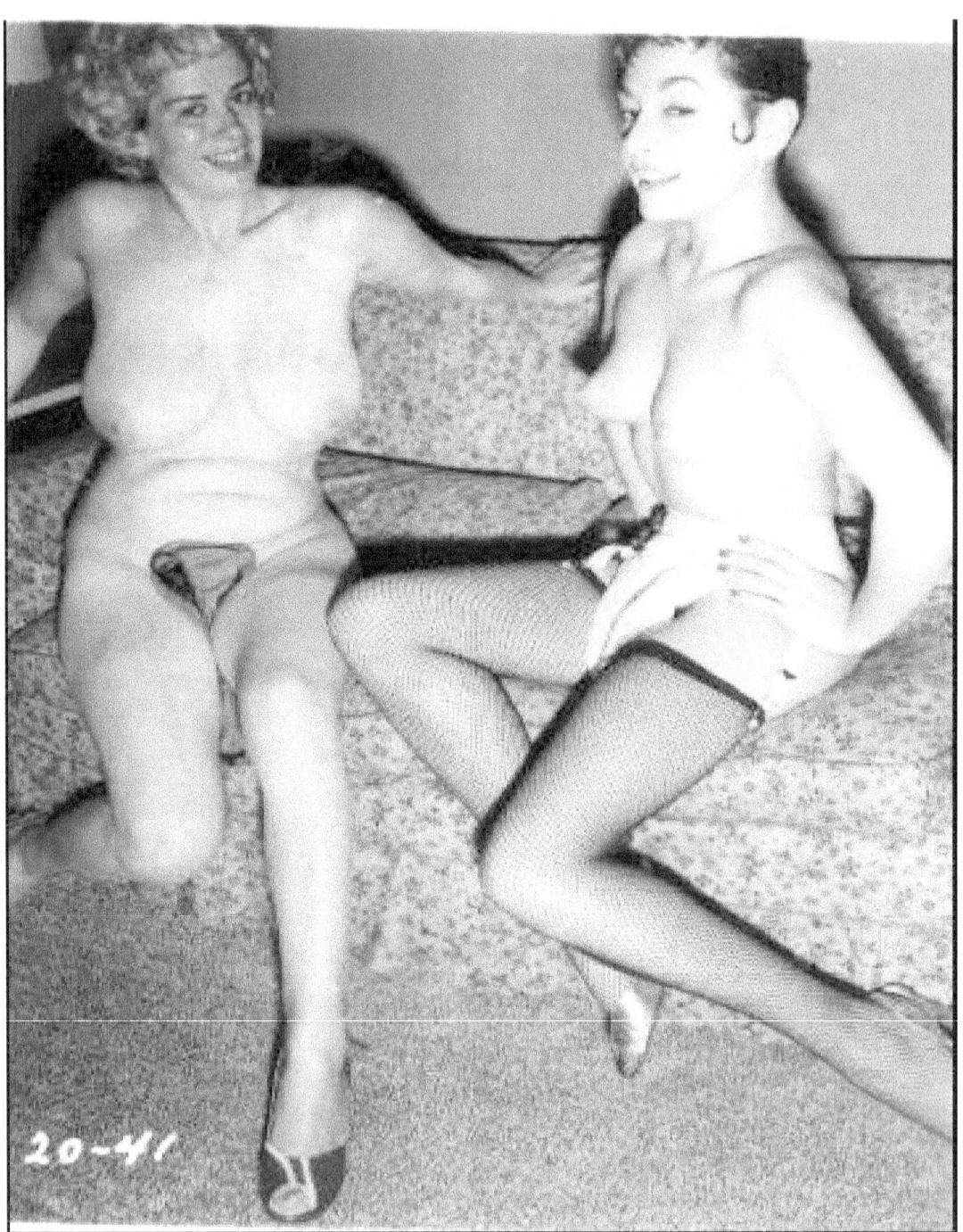

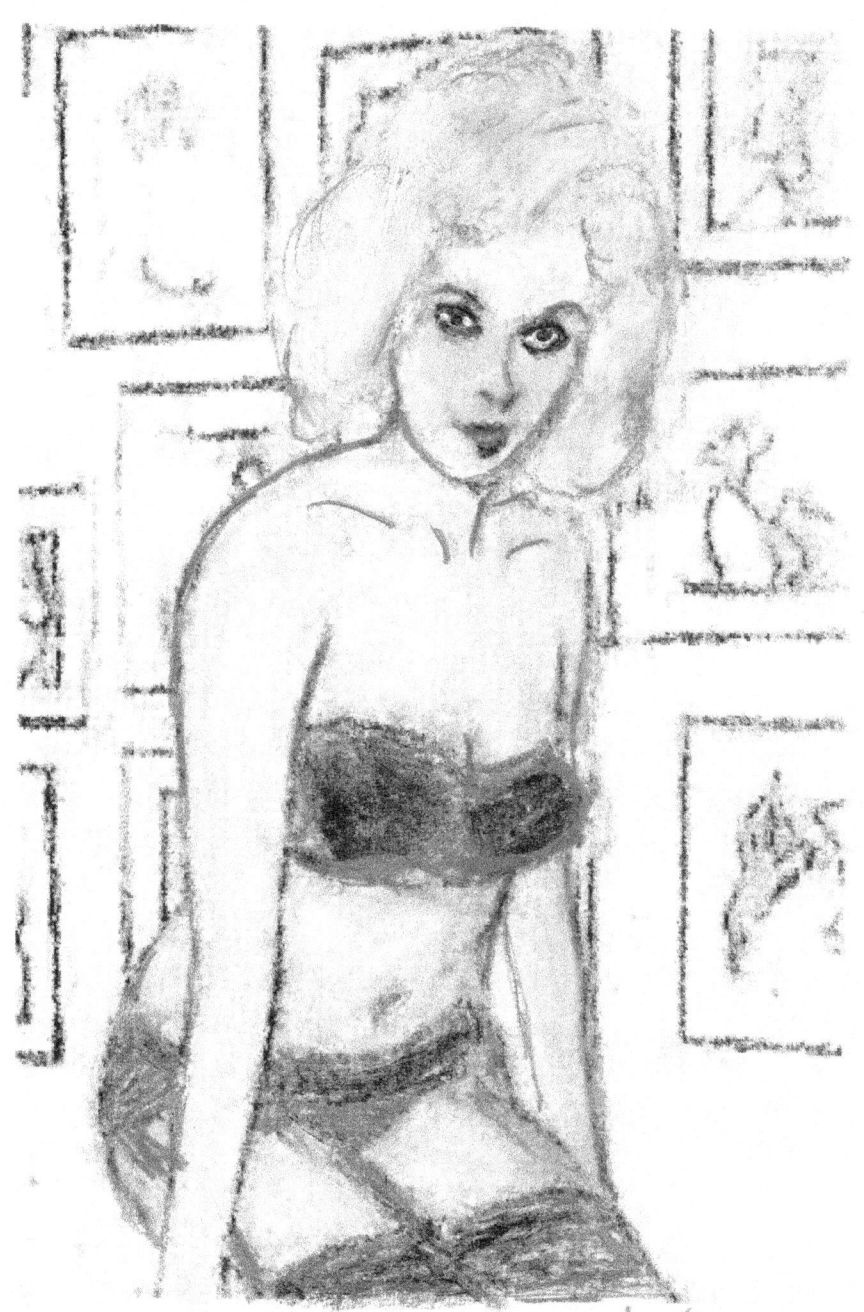

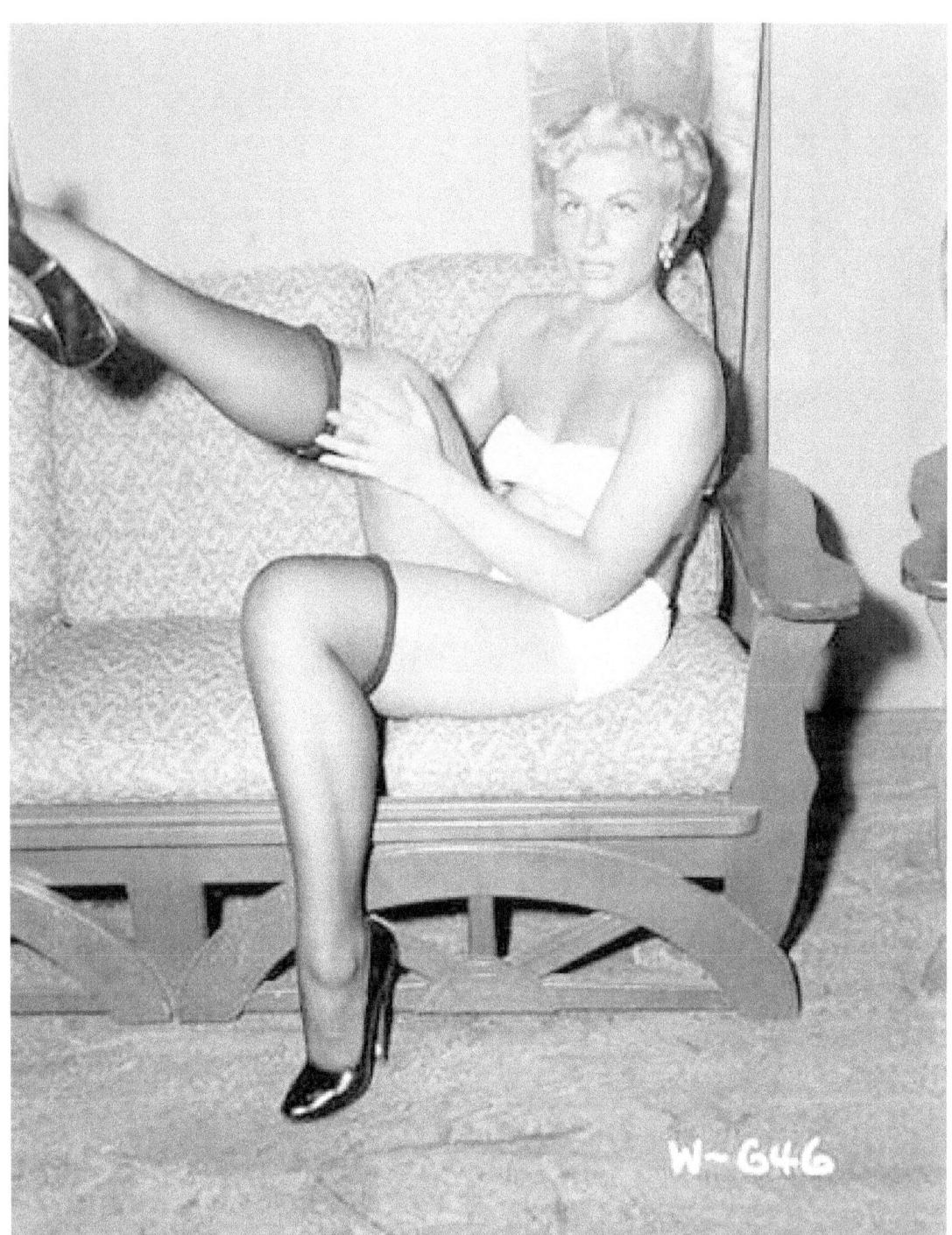

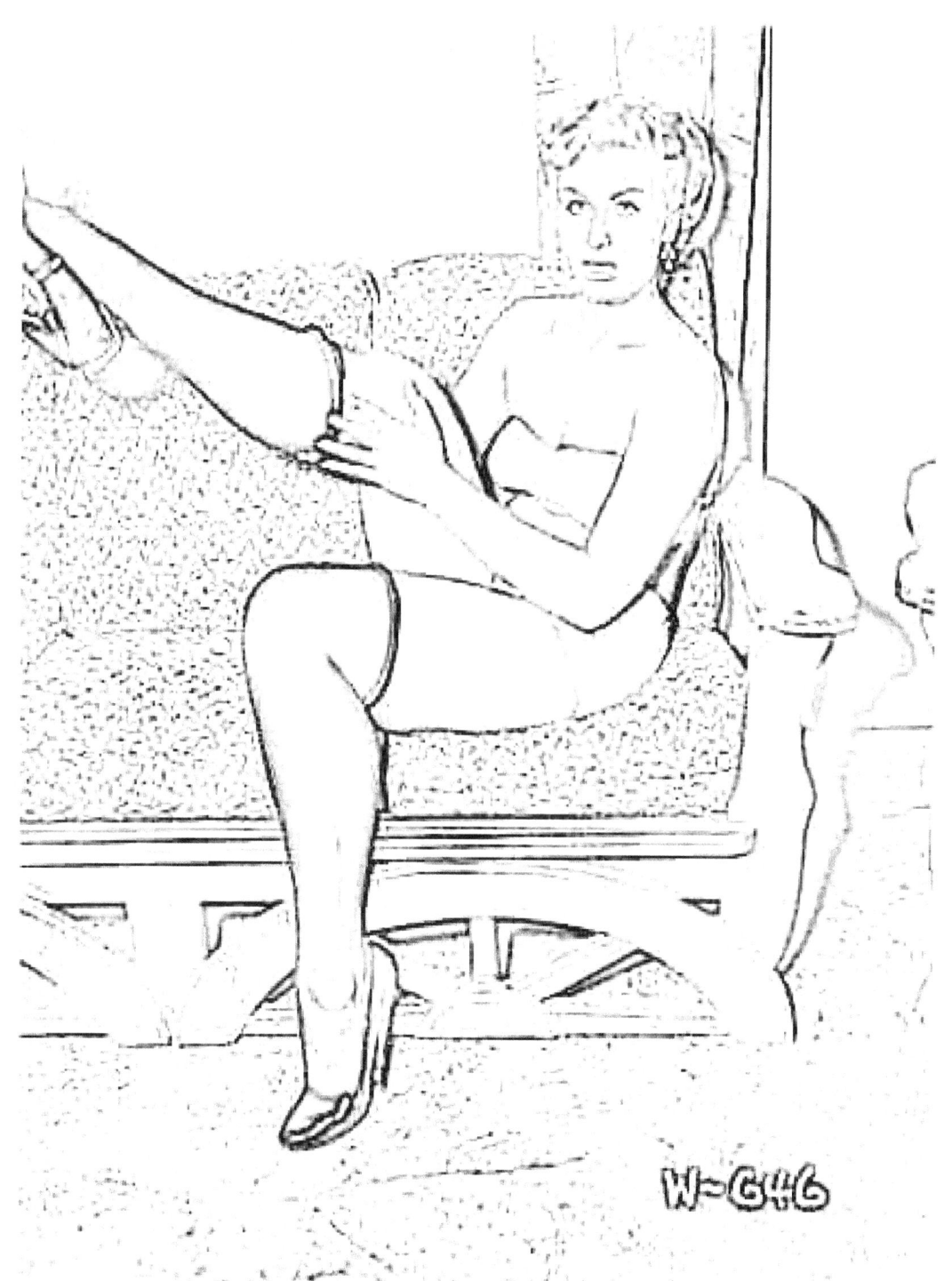

W-646

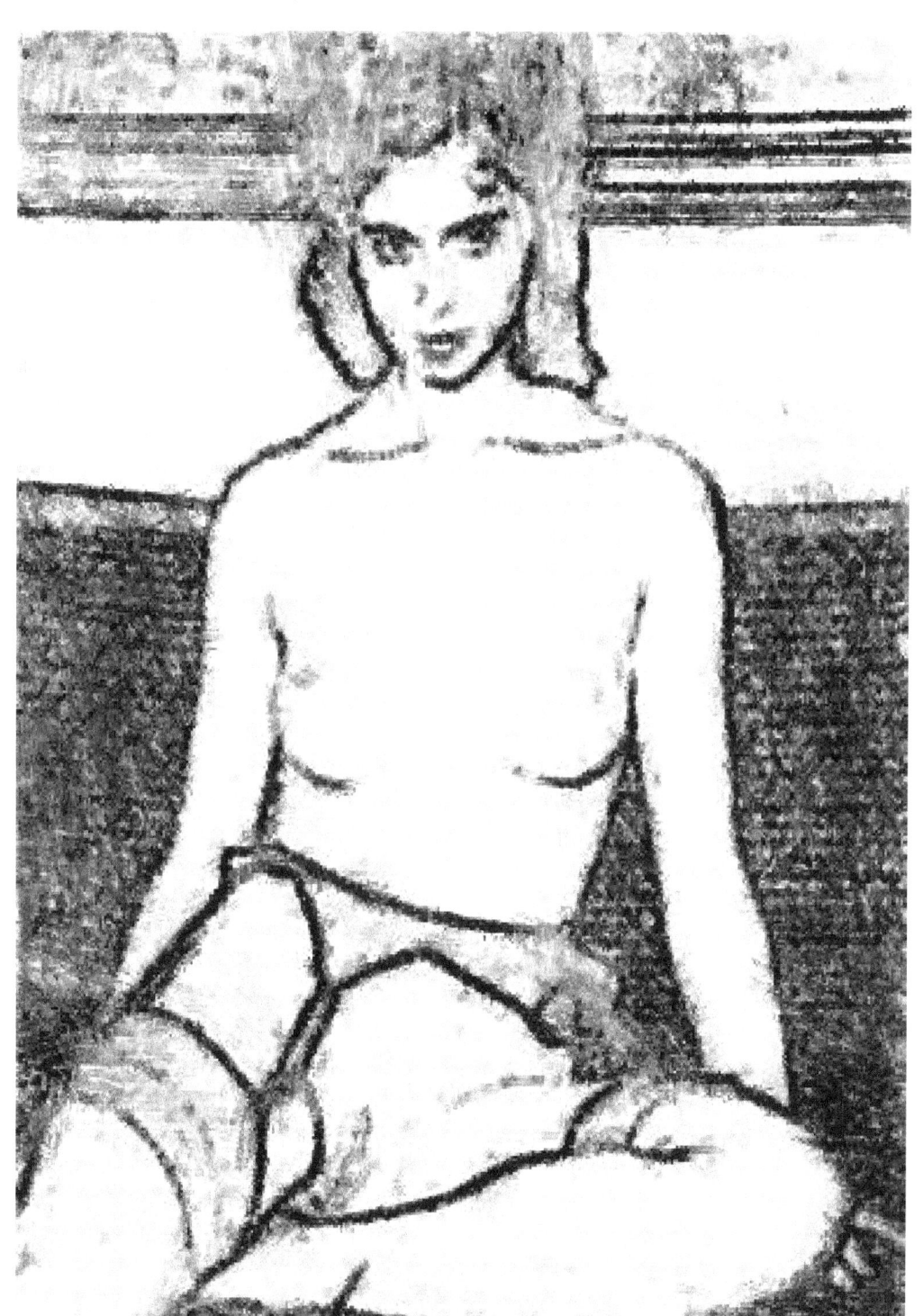

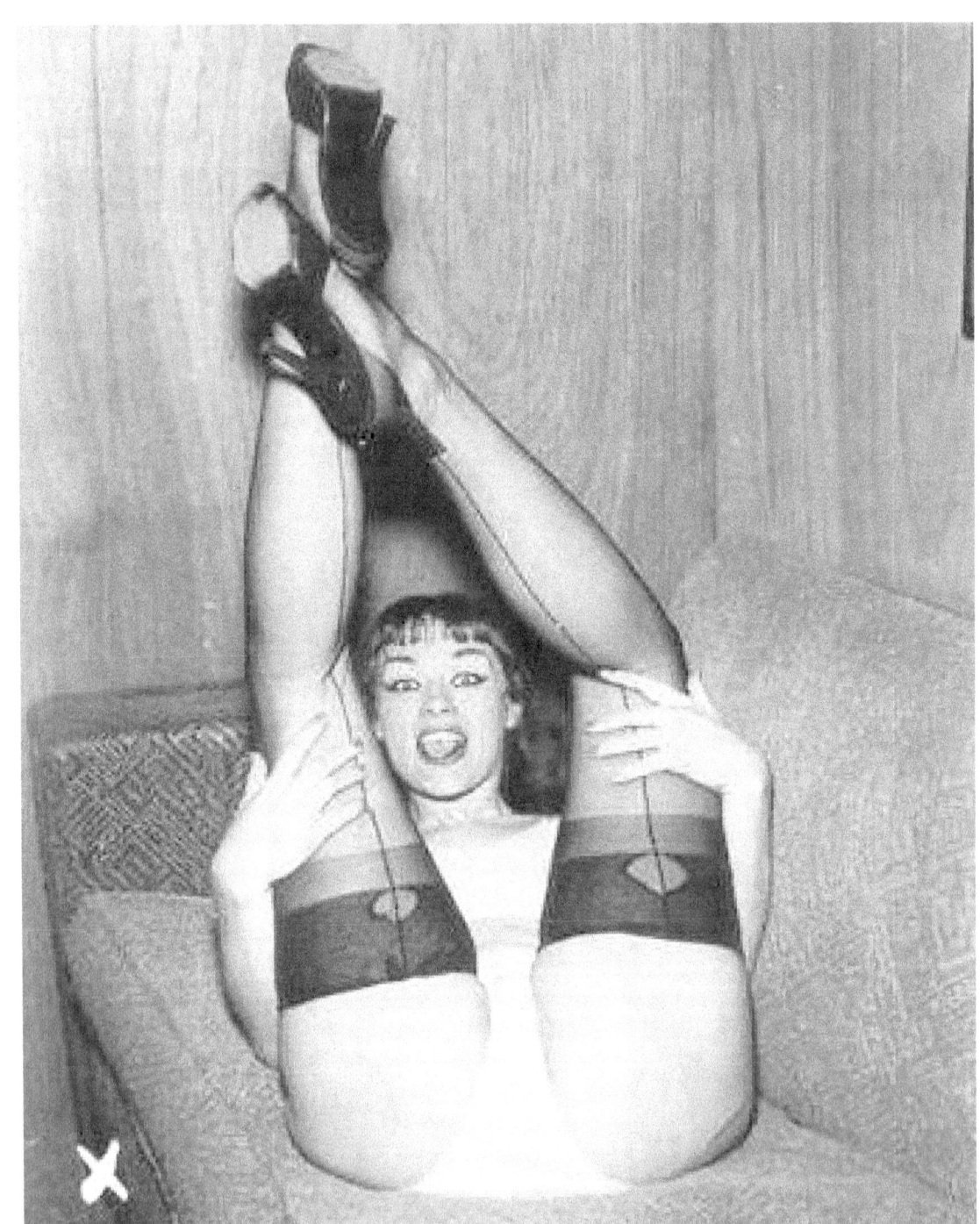

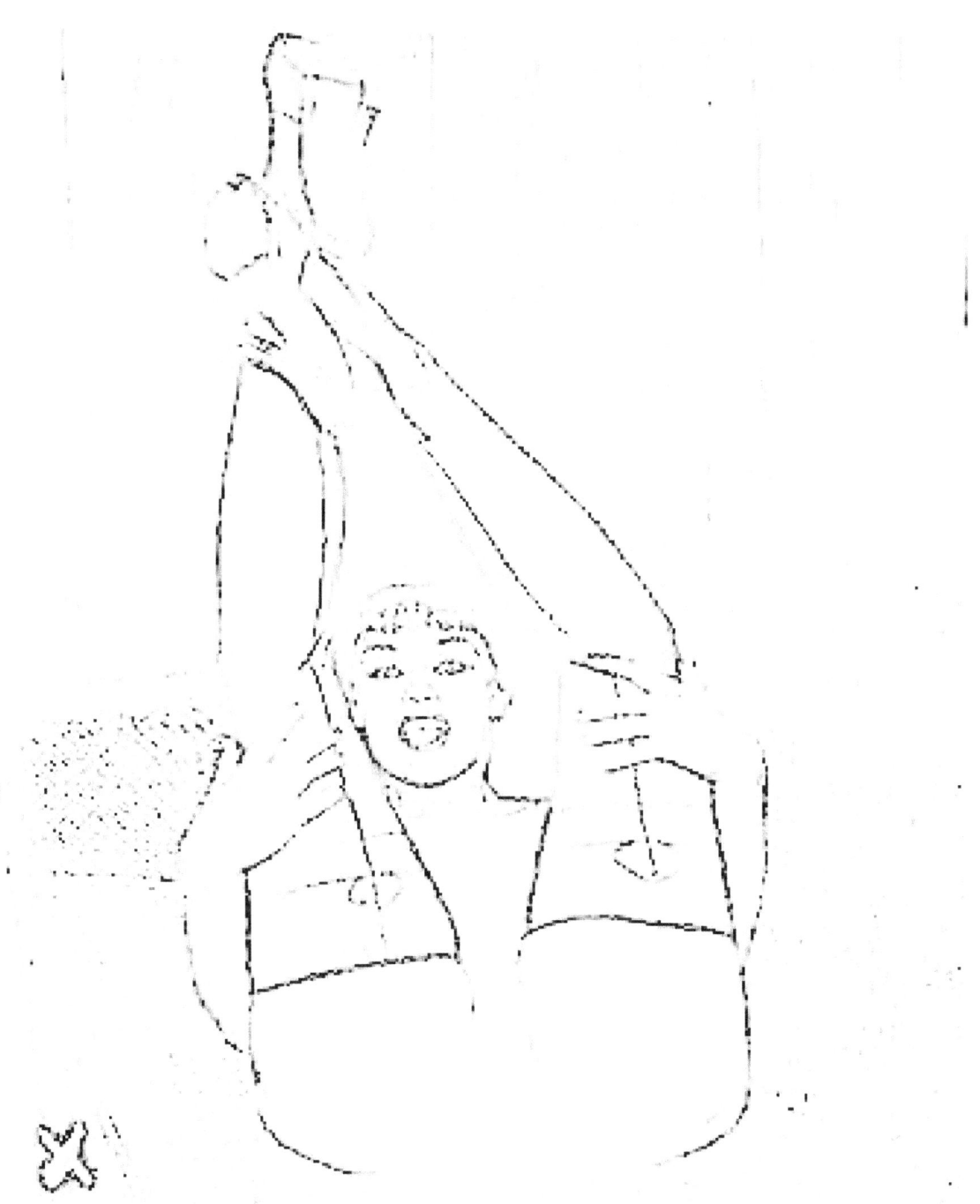

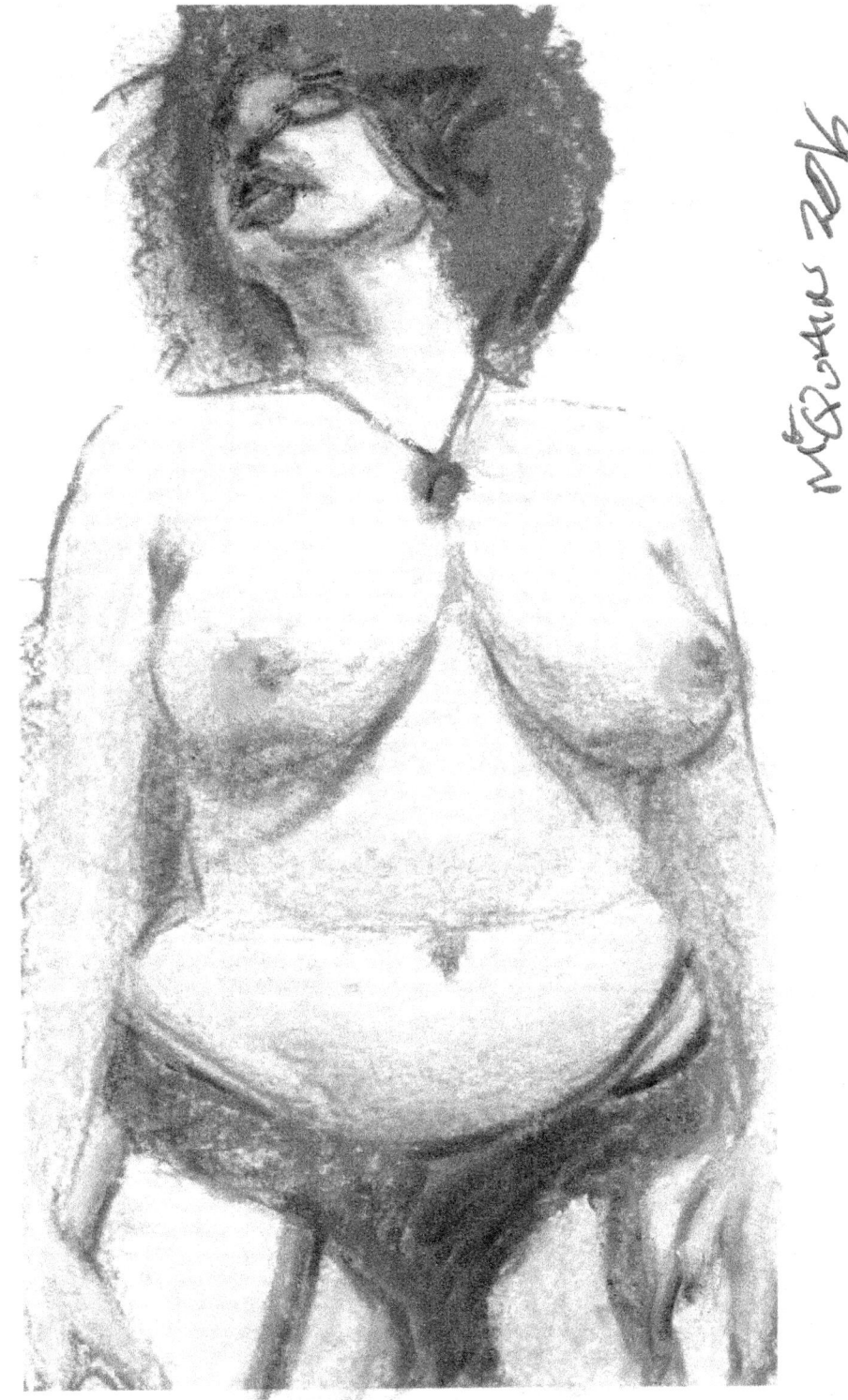

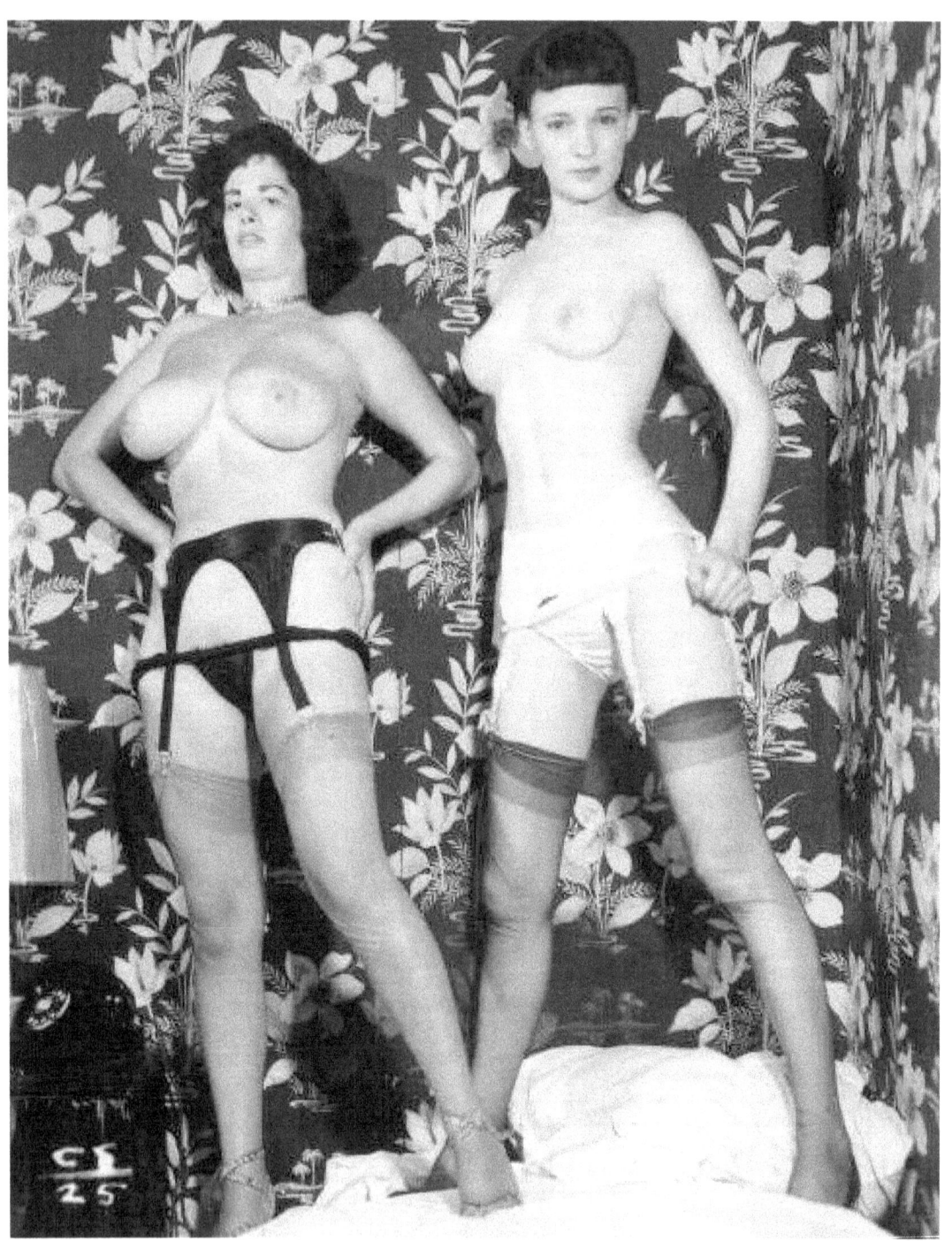

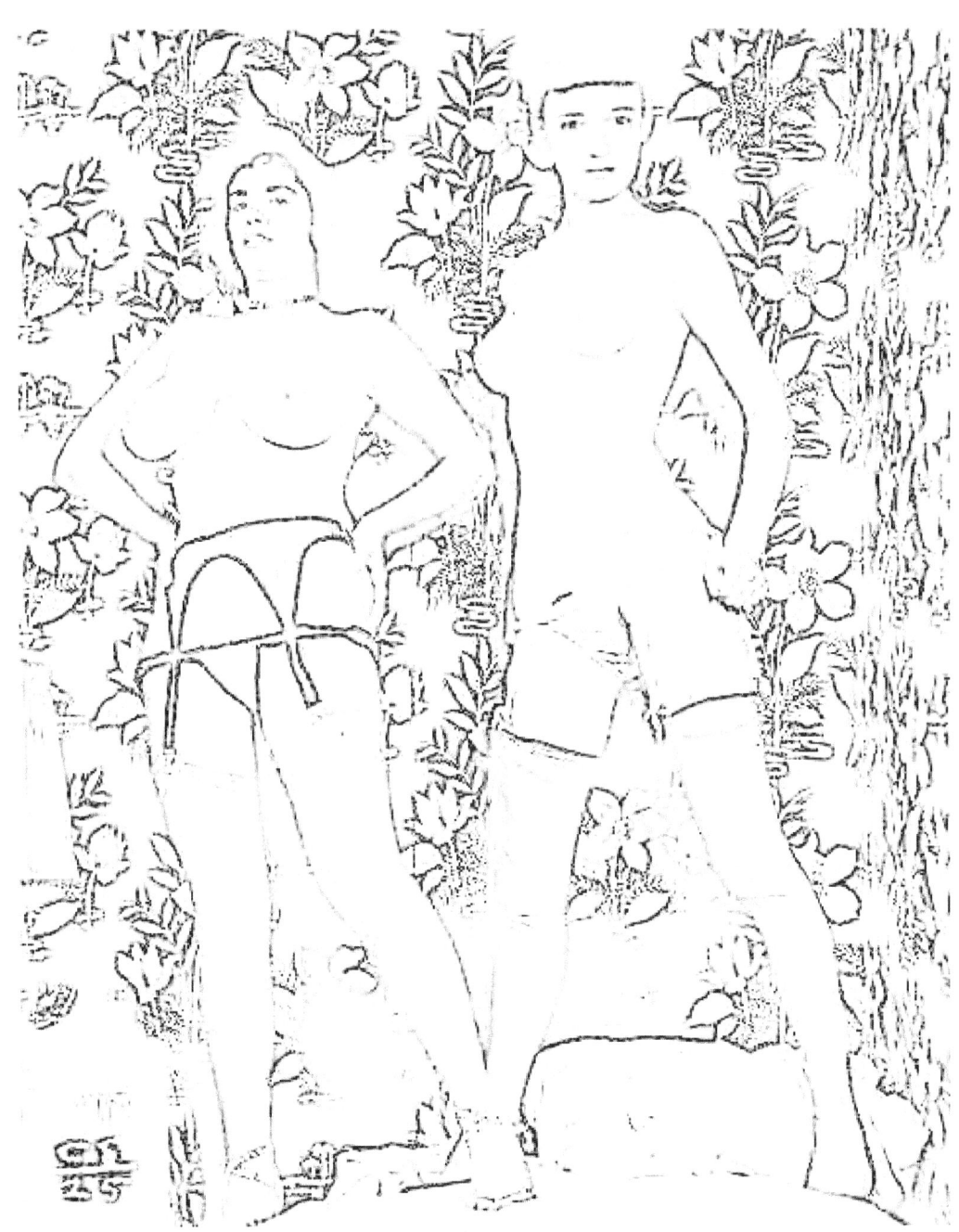

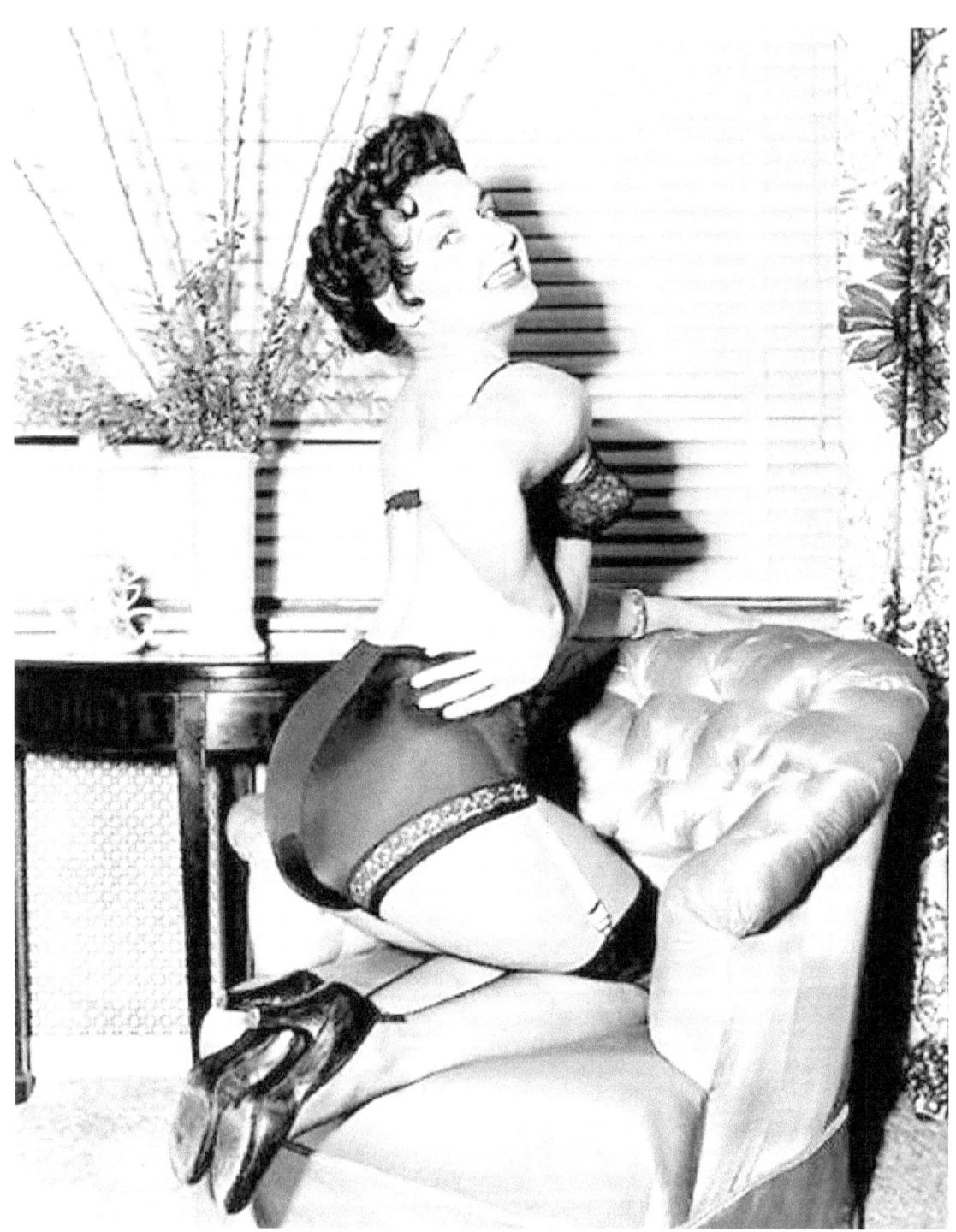

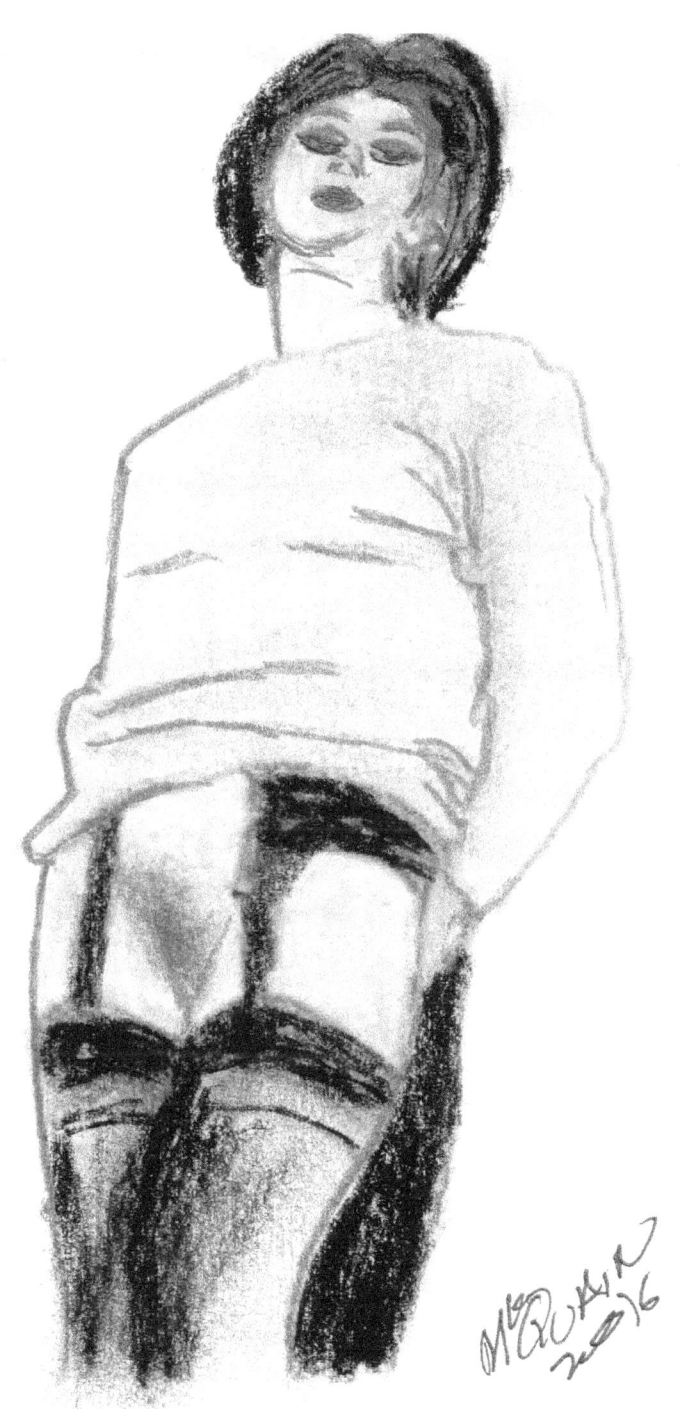

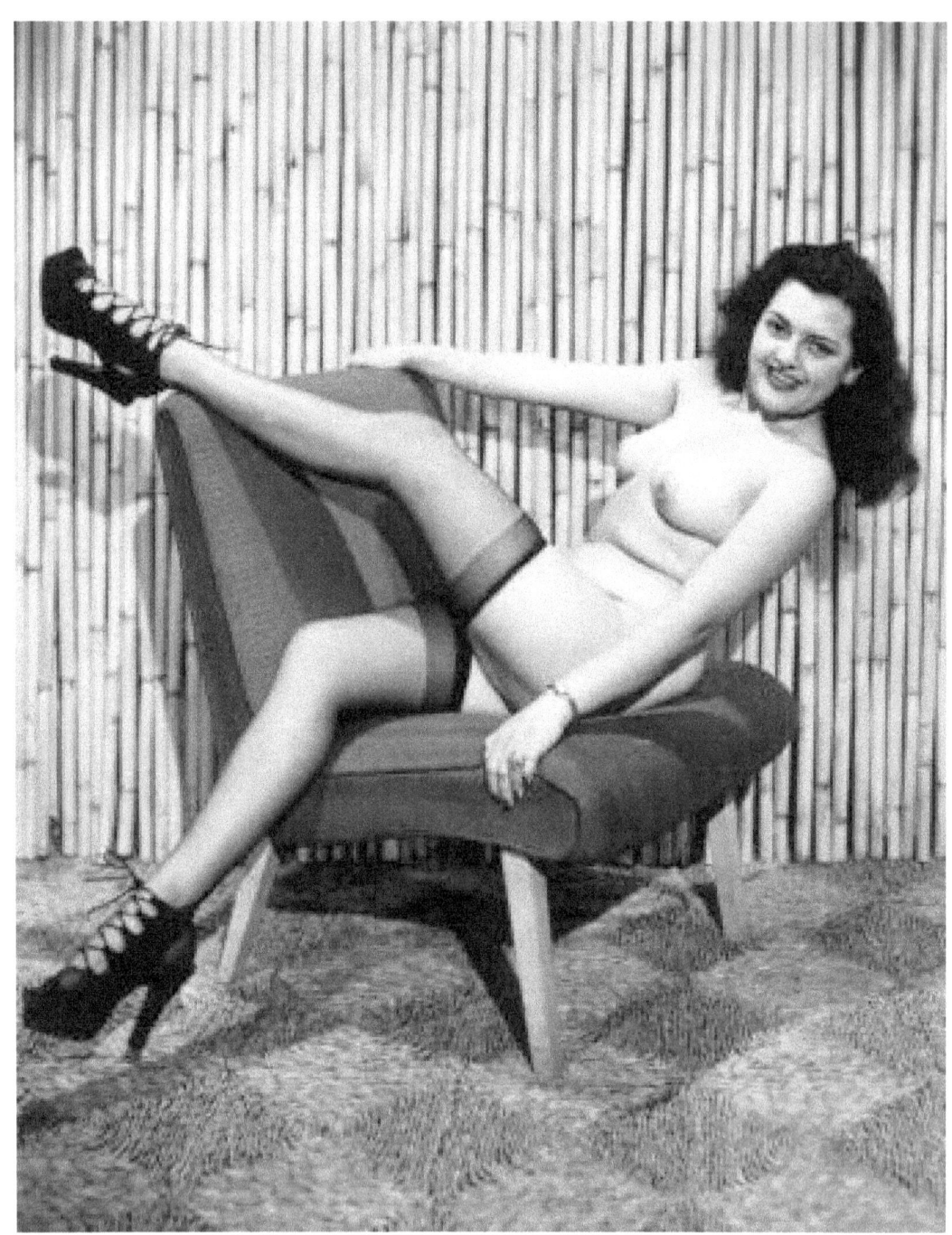

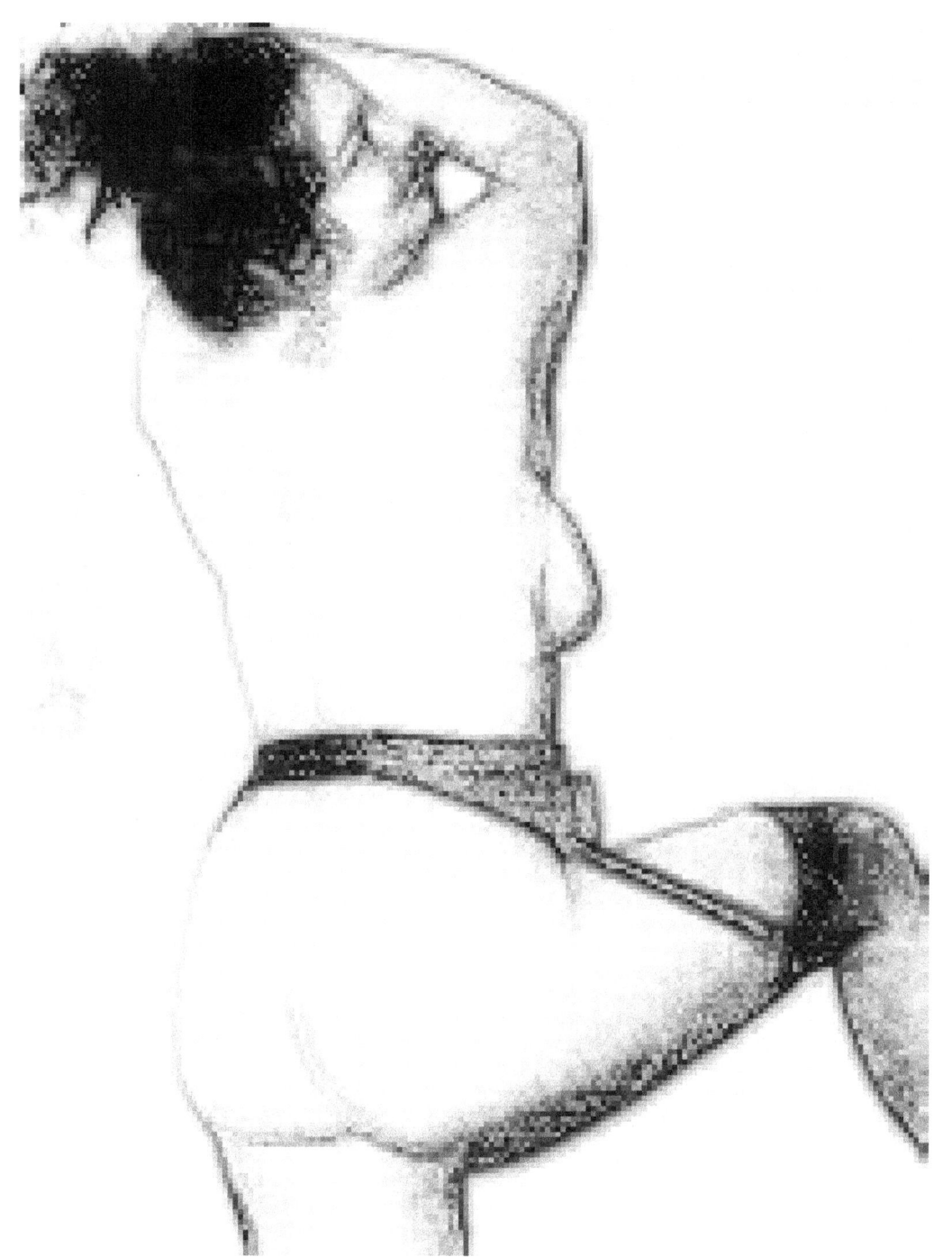

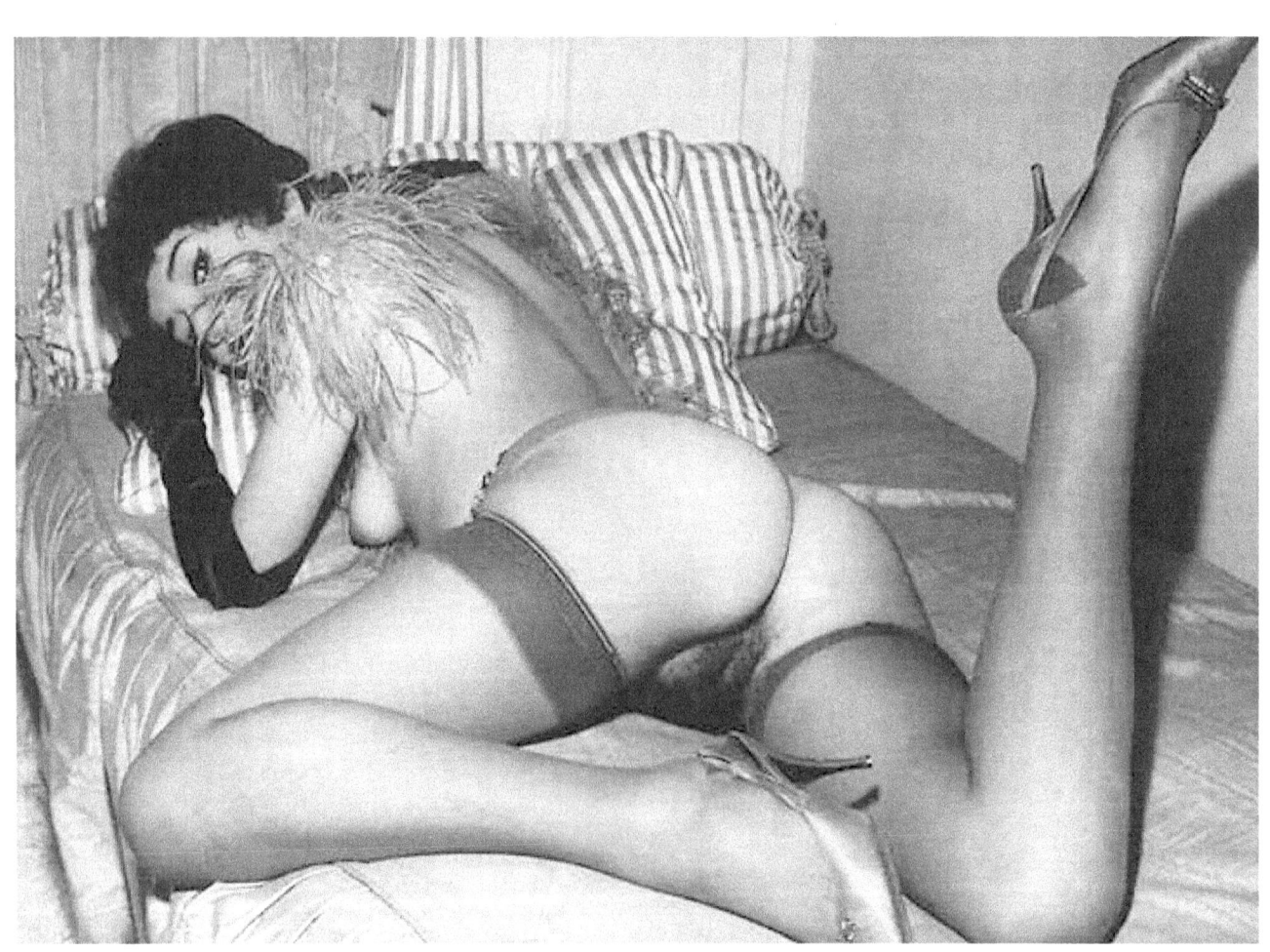

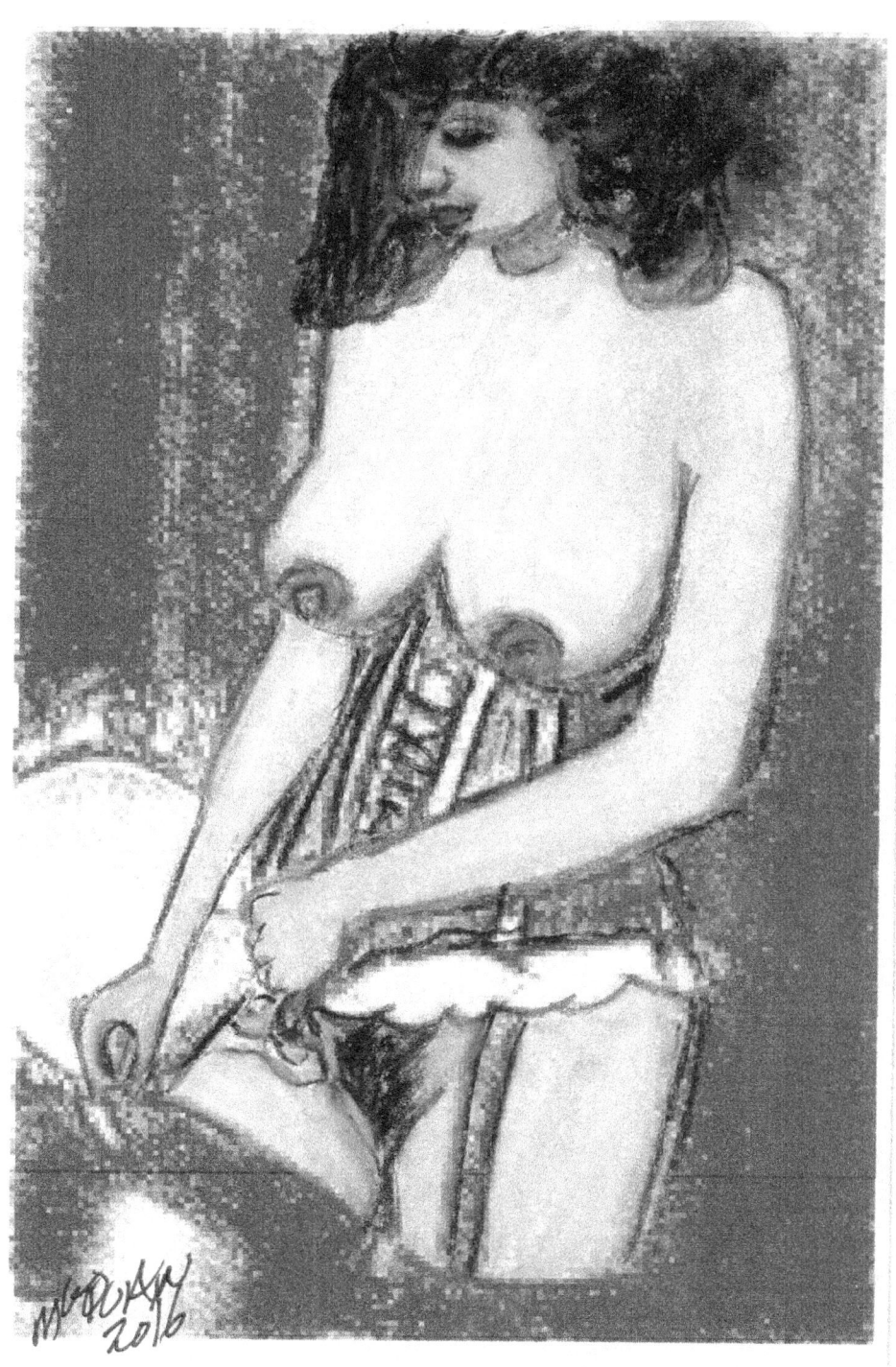

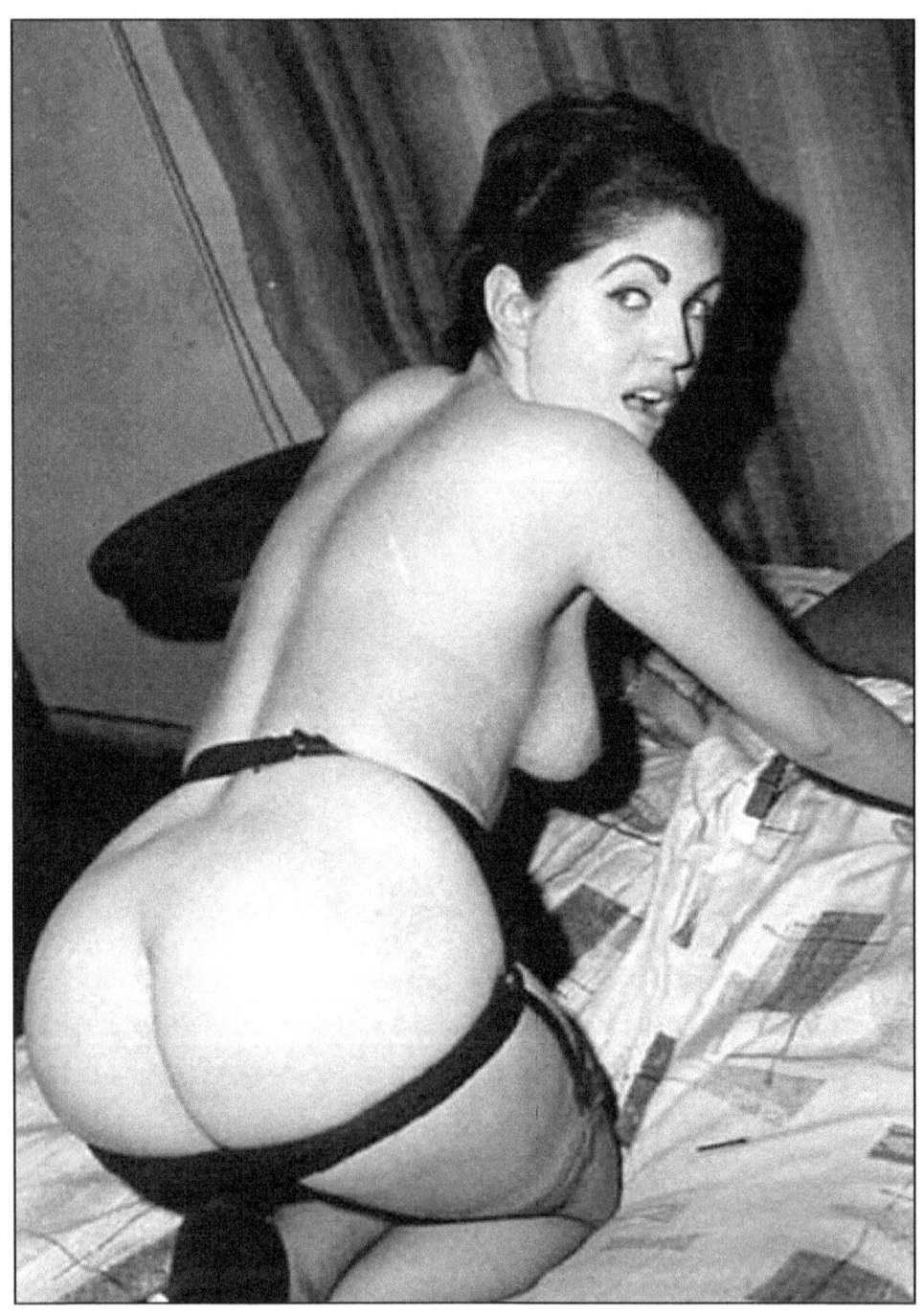

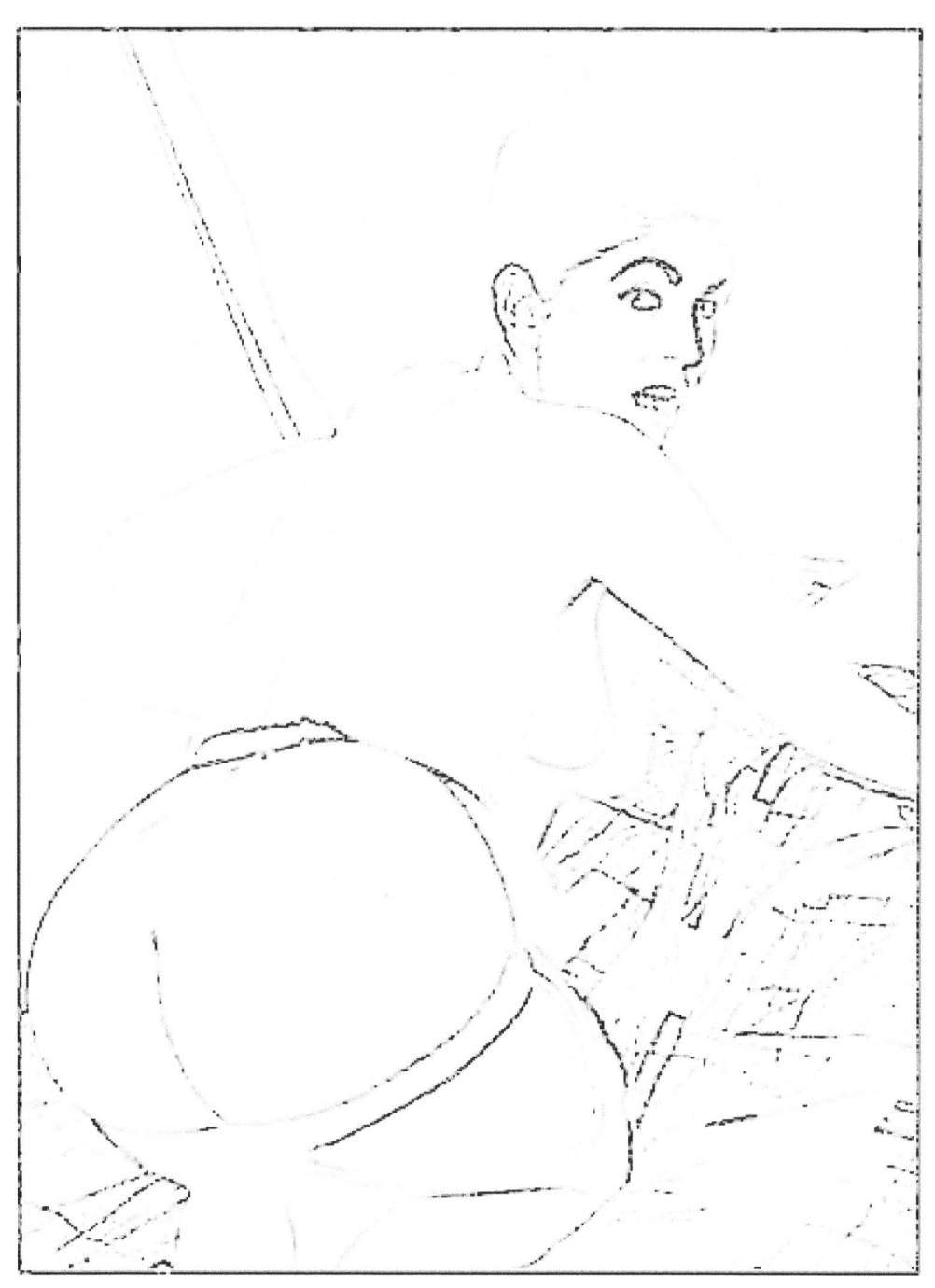

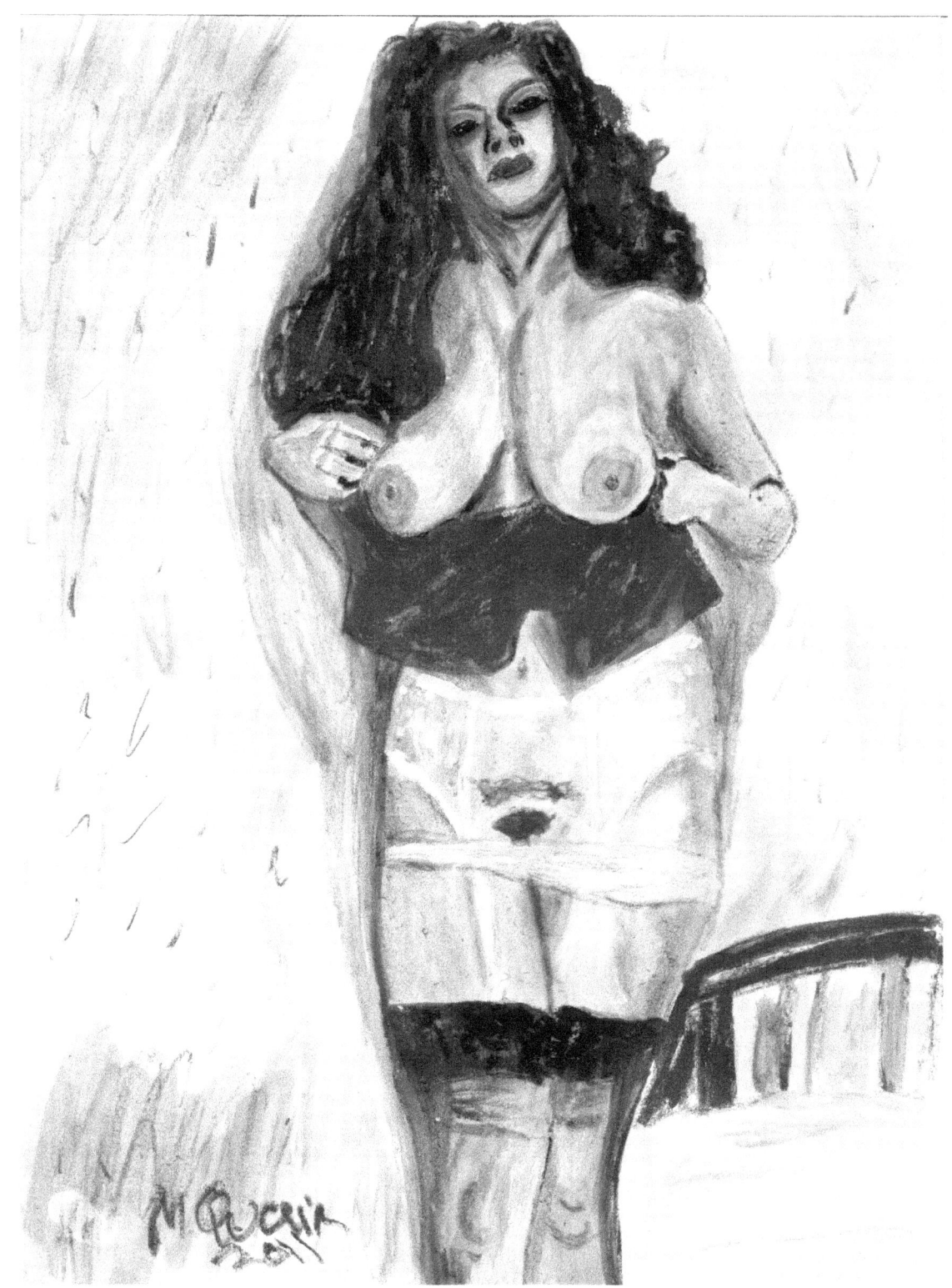

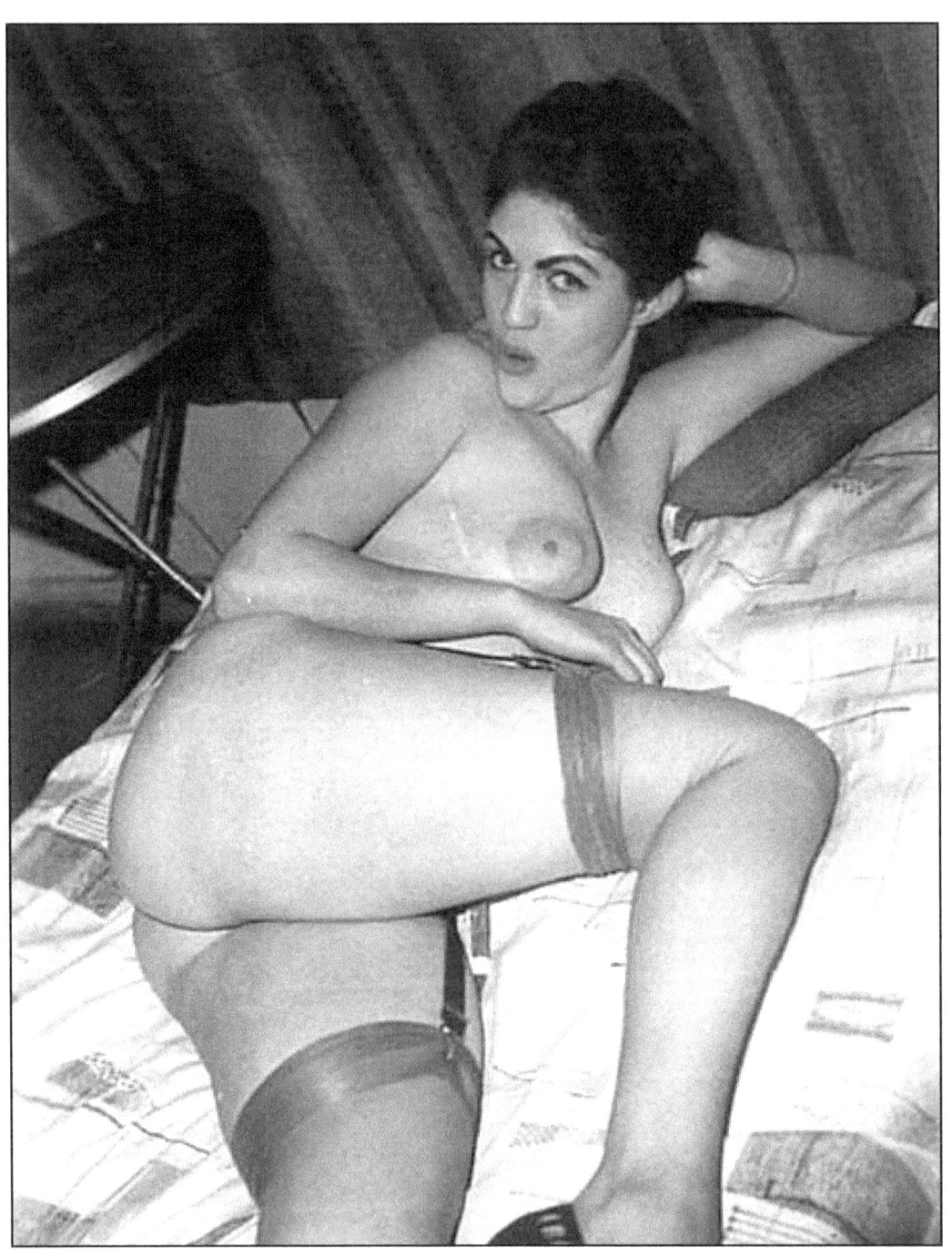

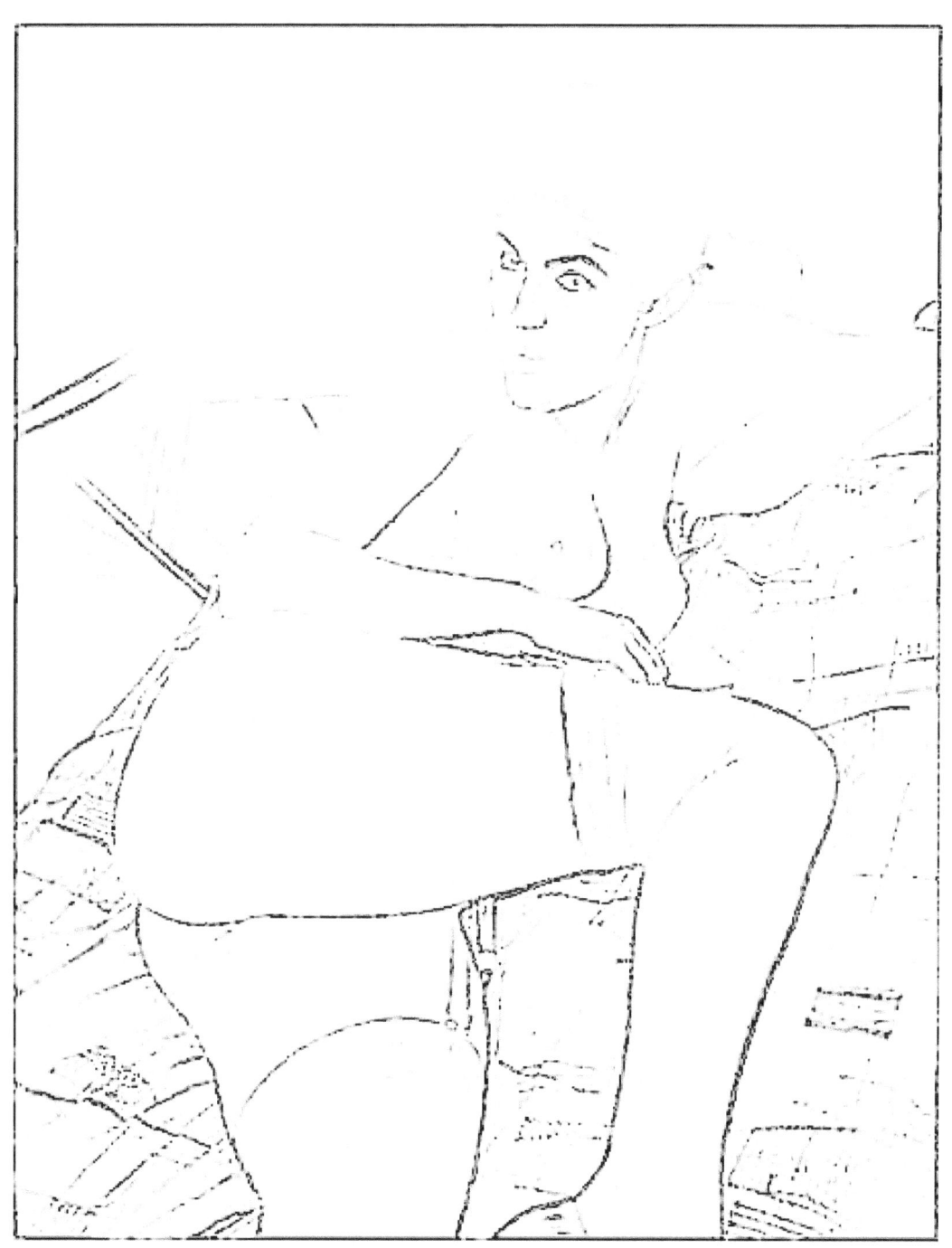

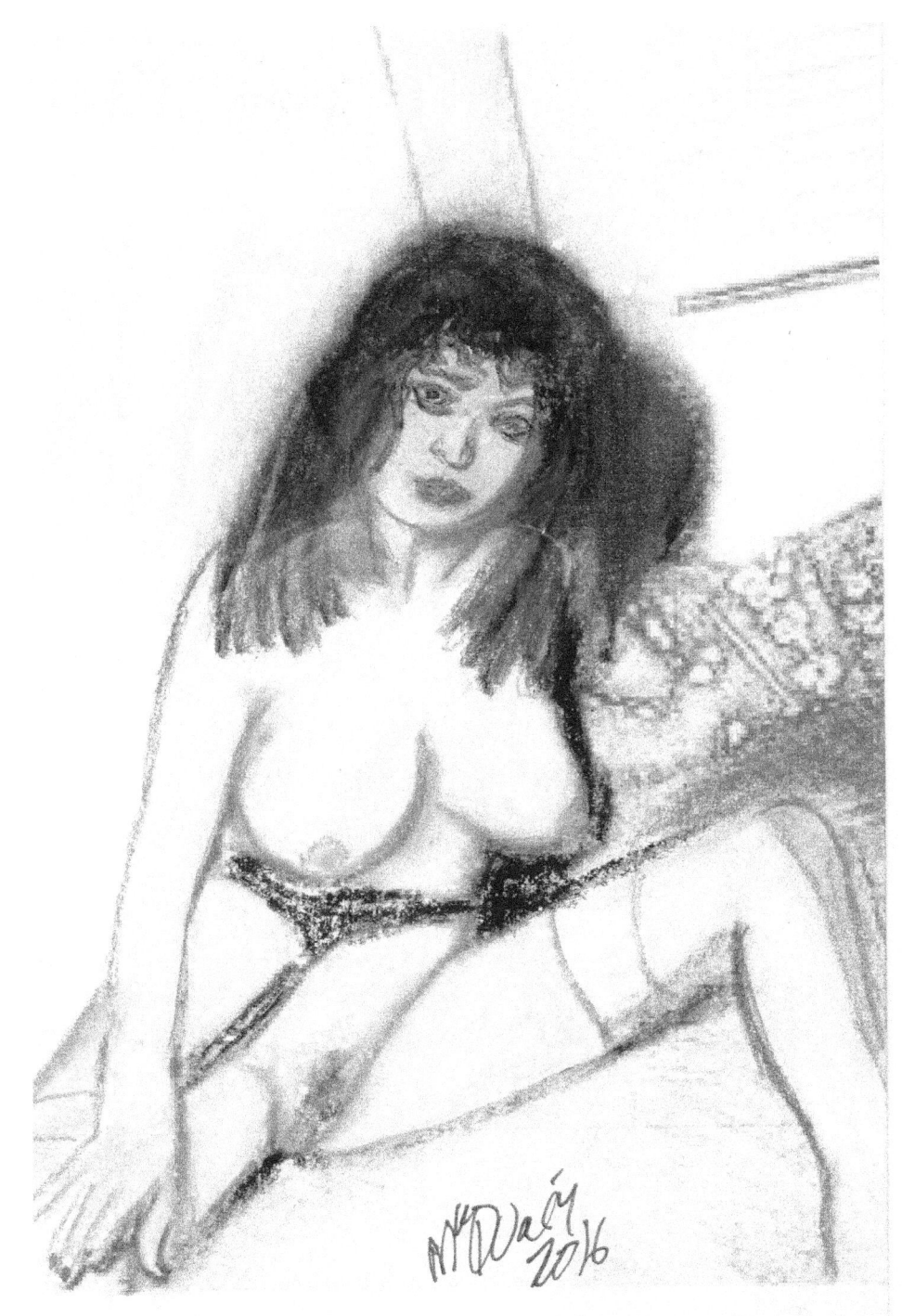

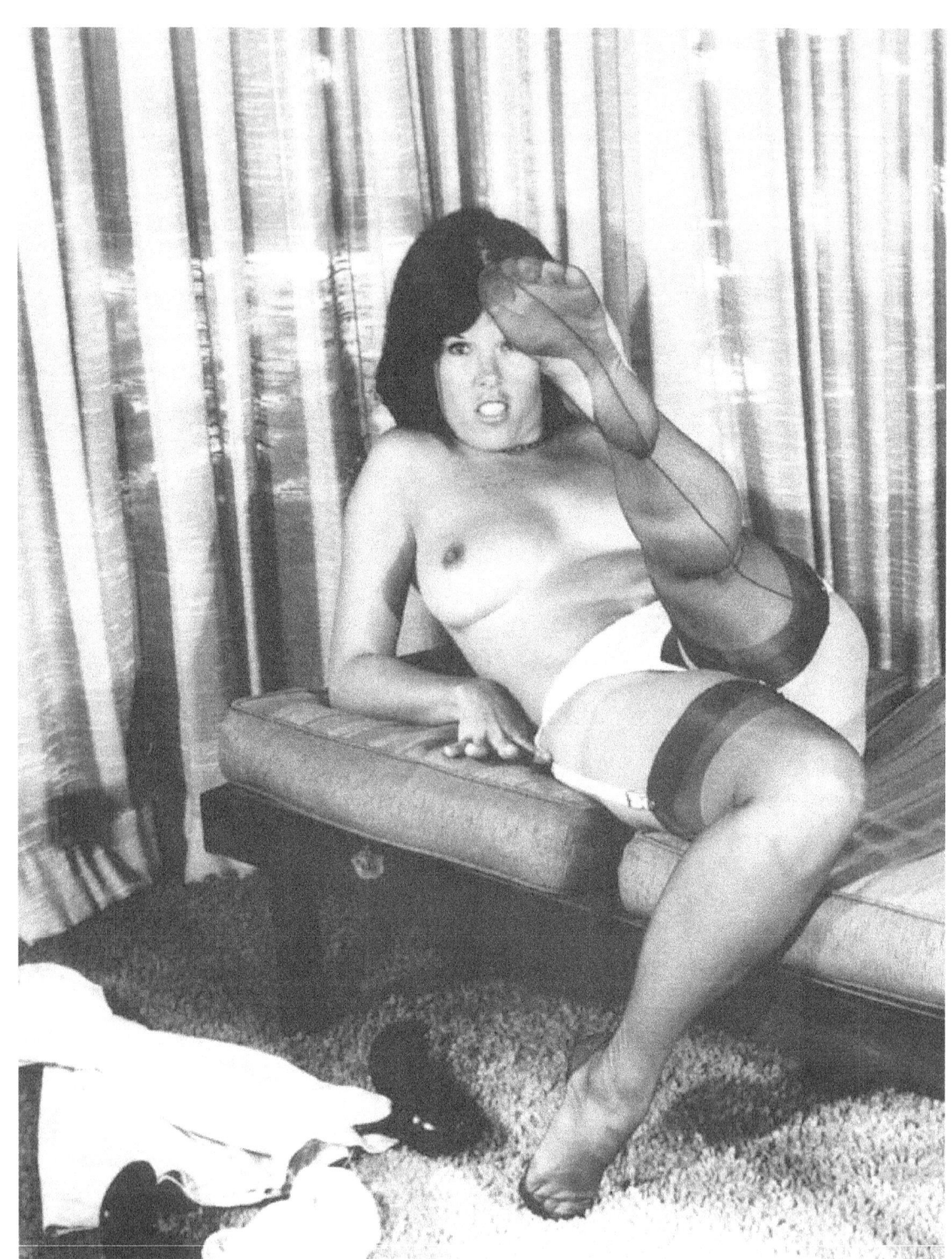

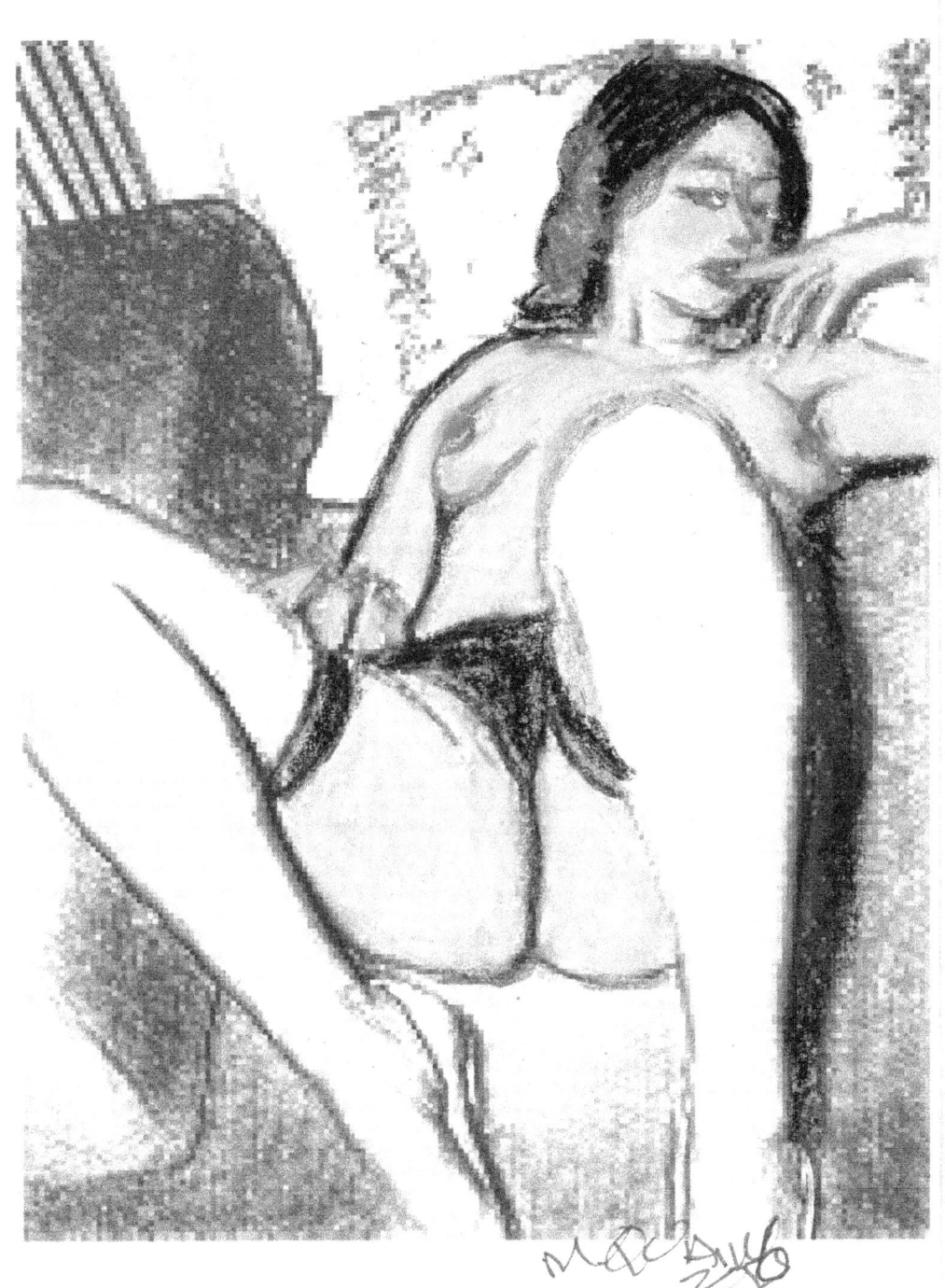

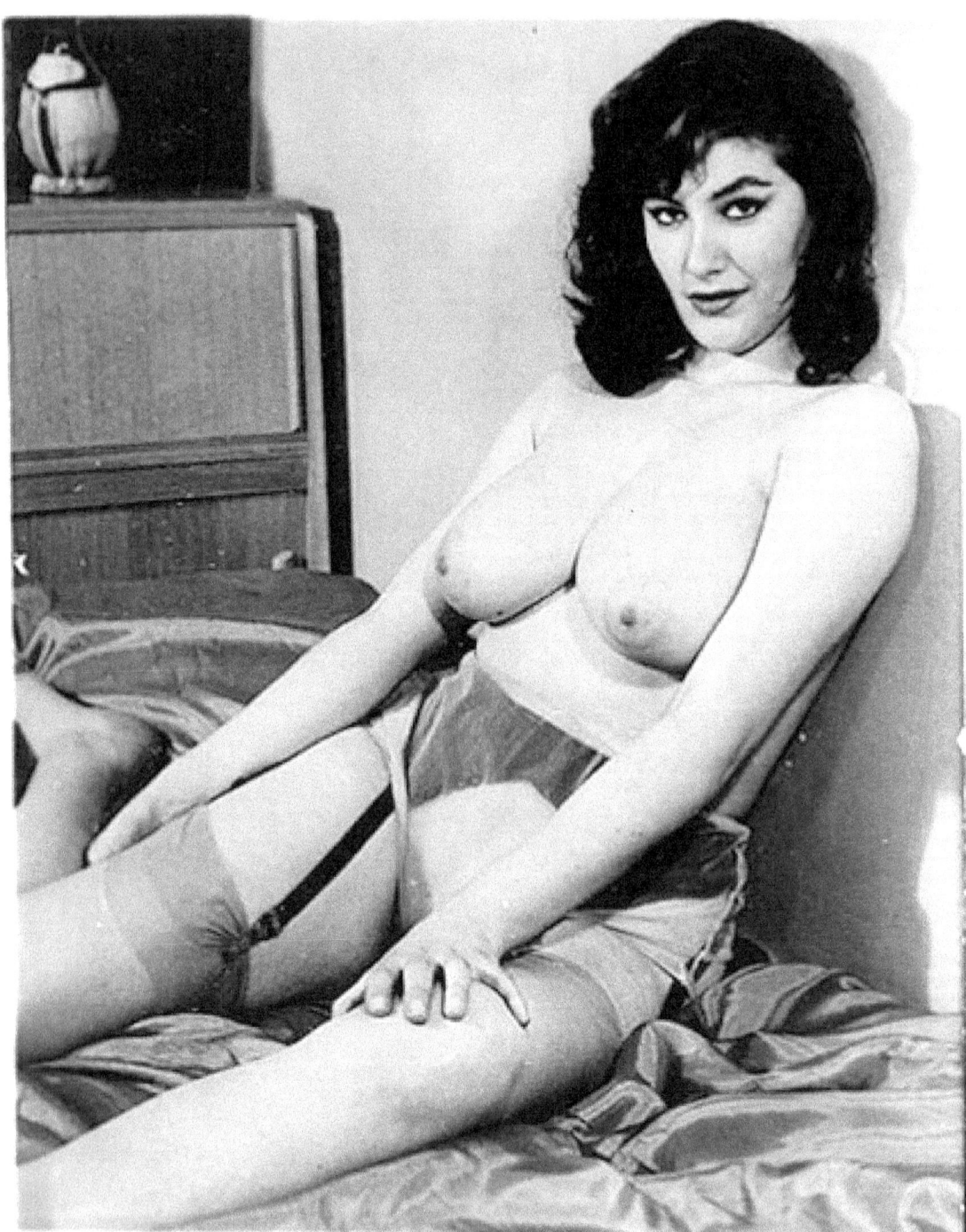

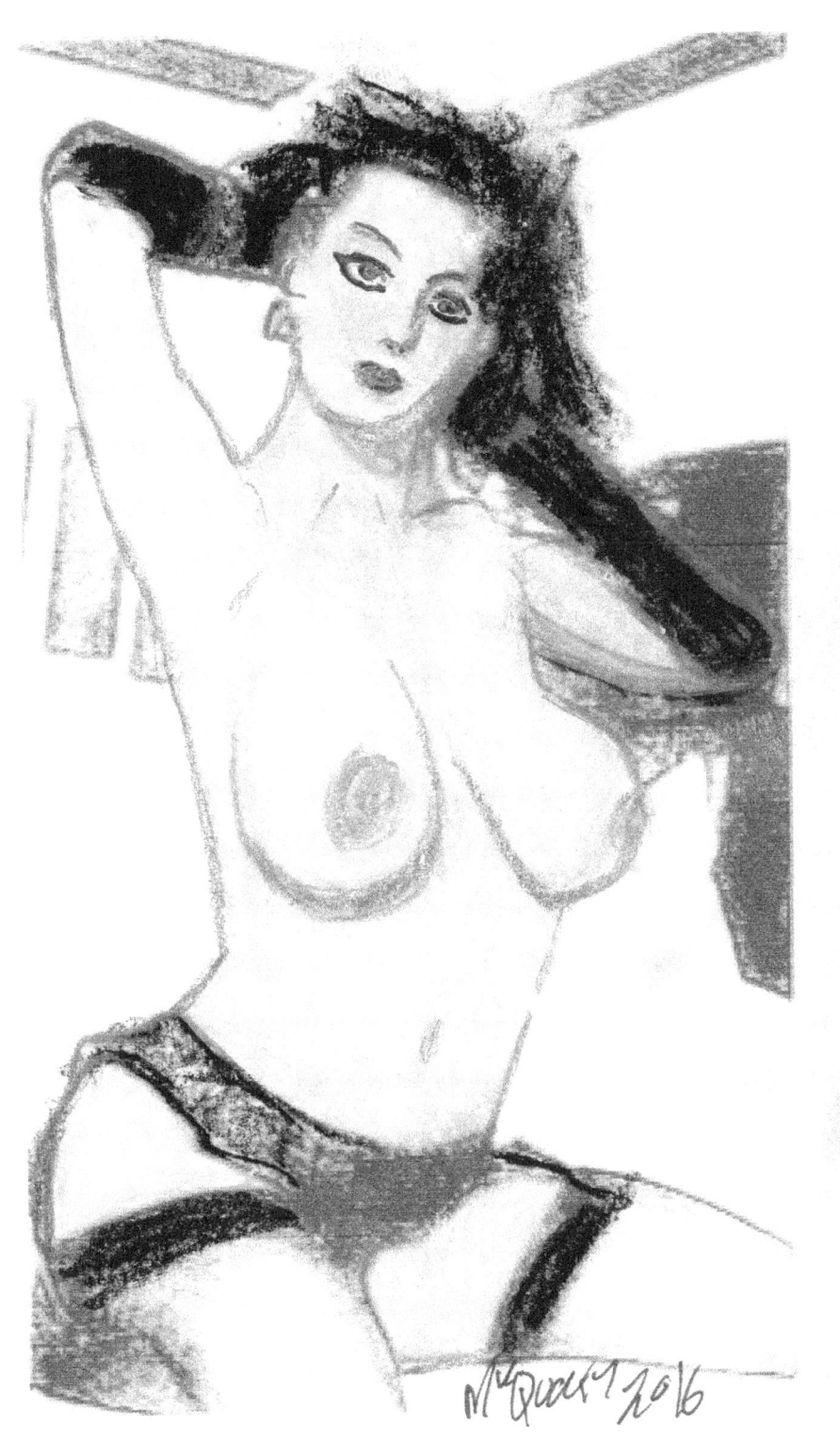

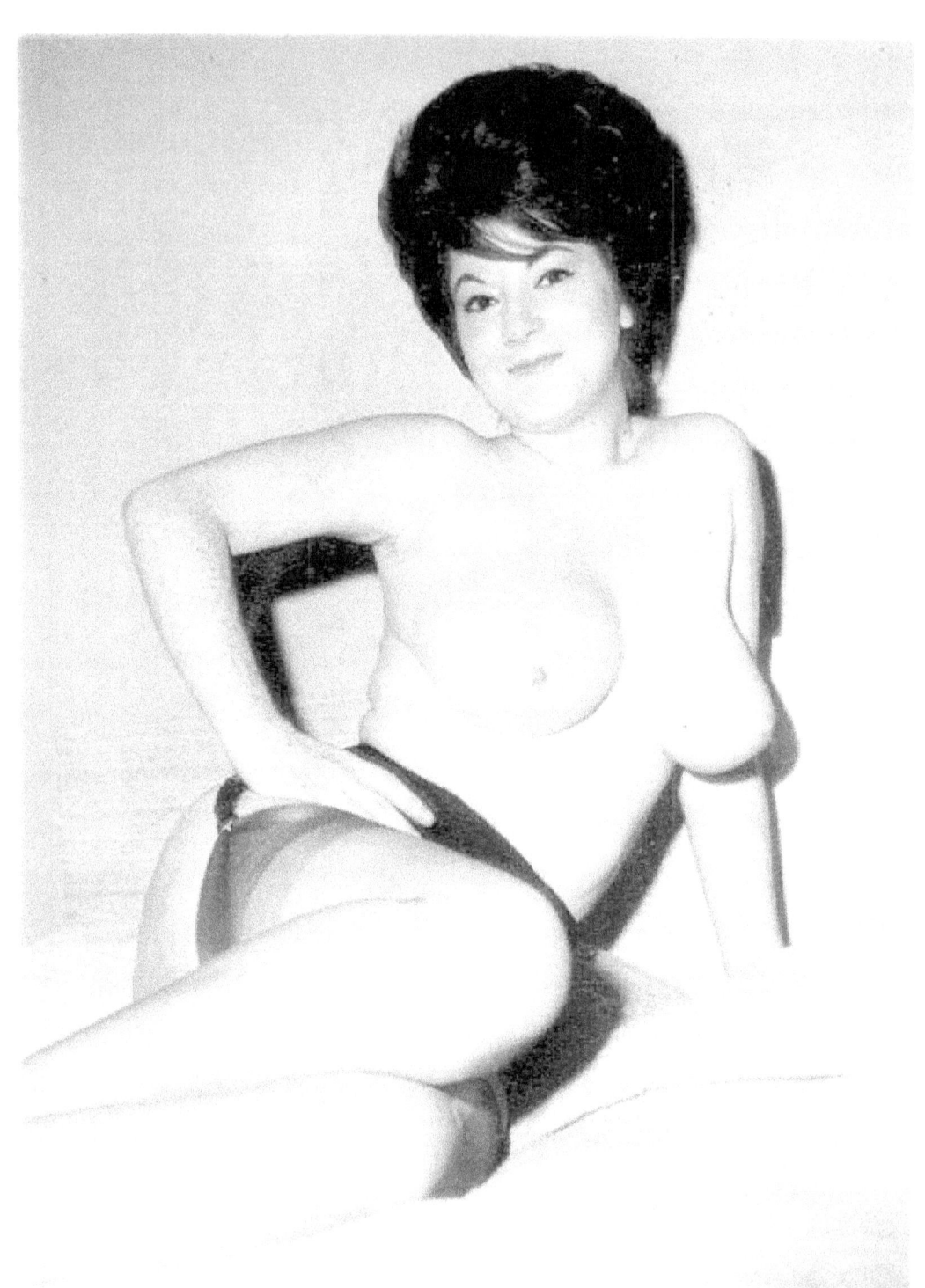

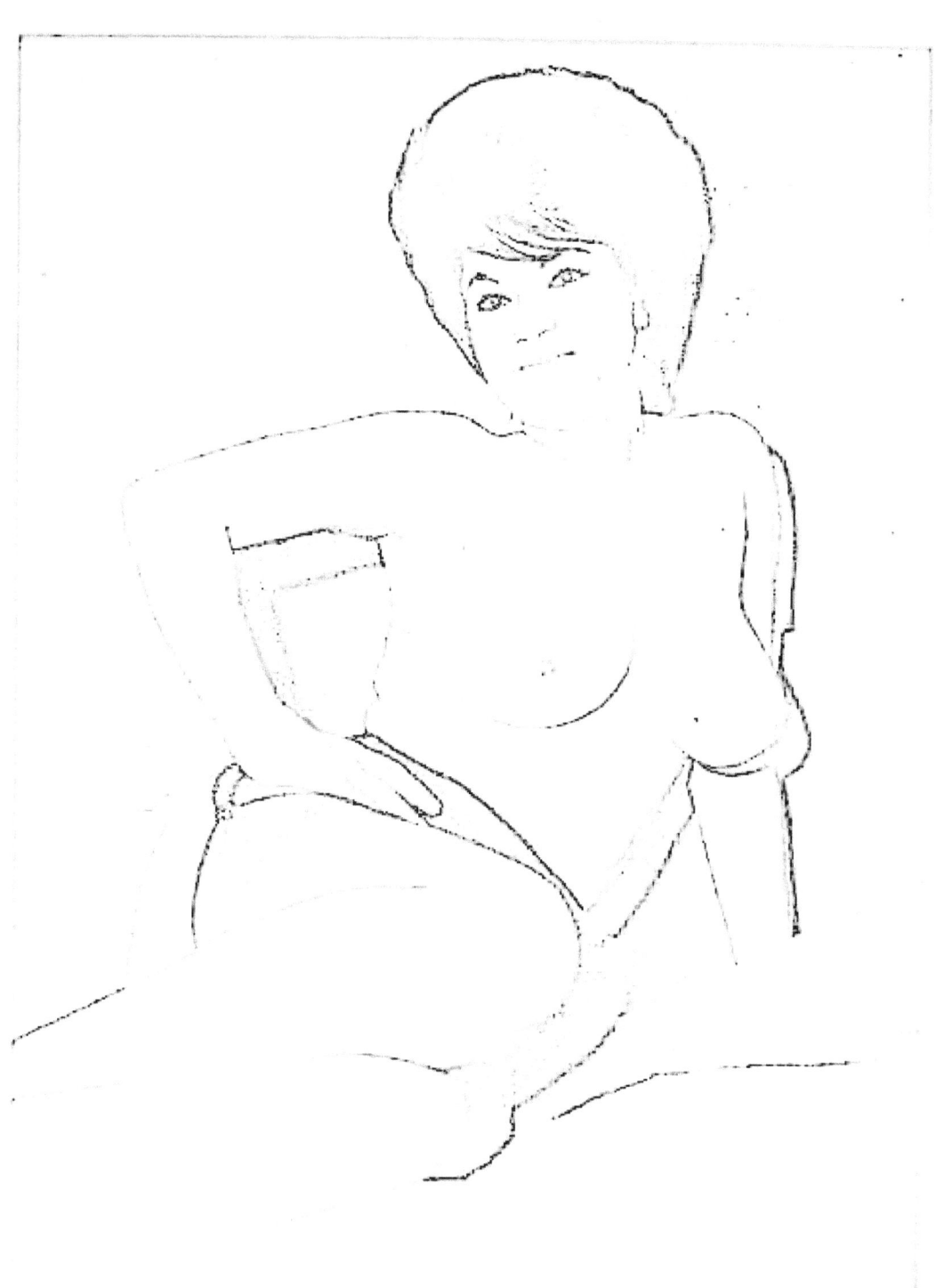

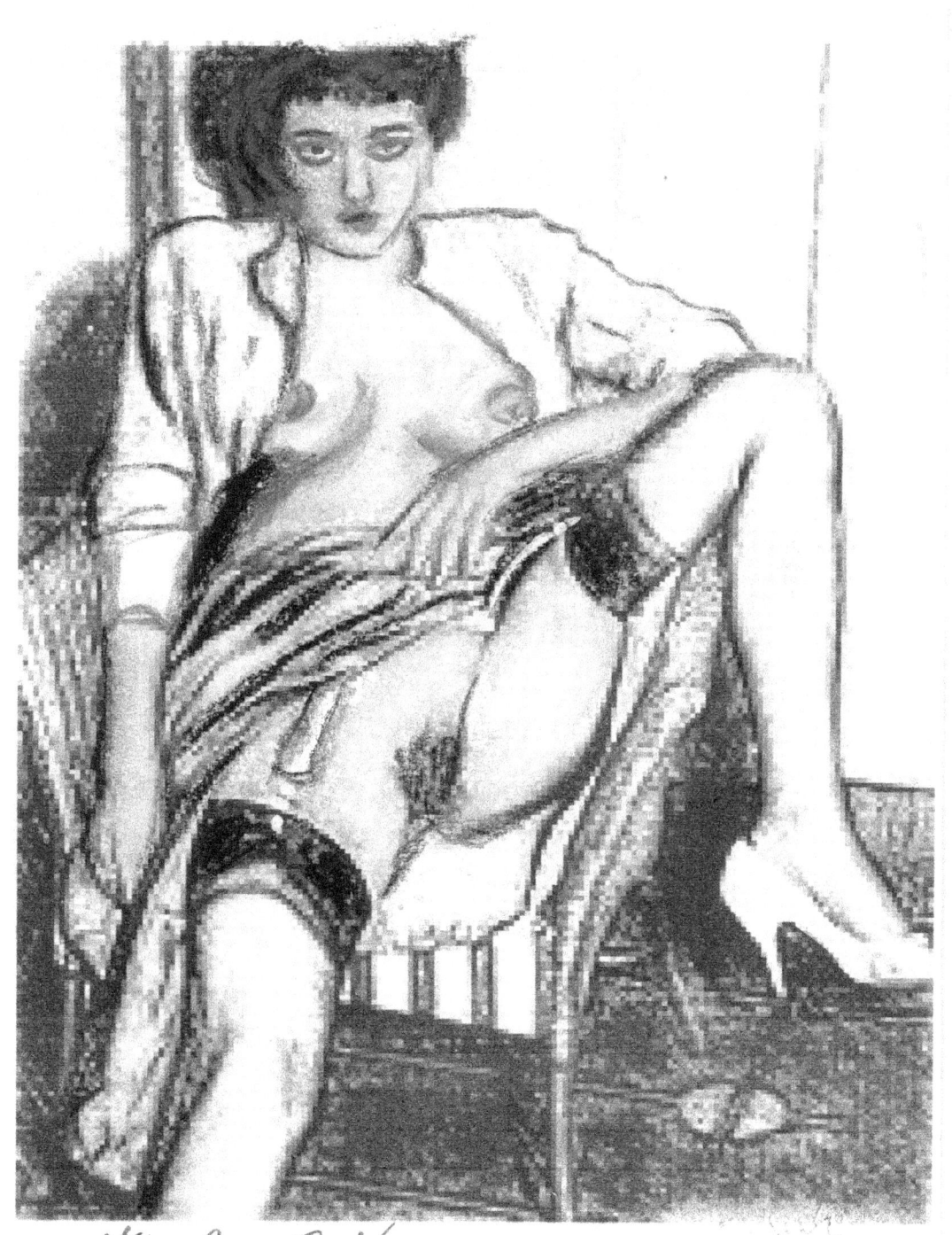

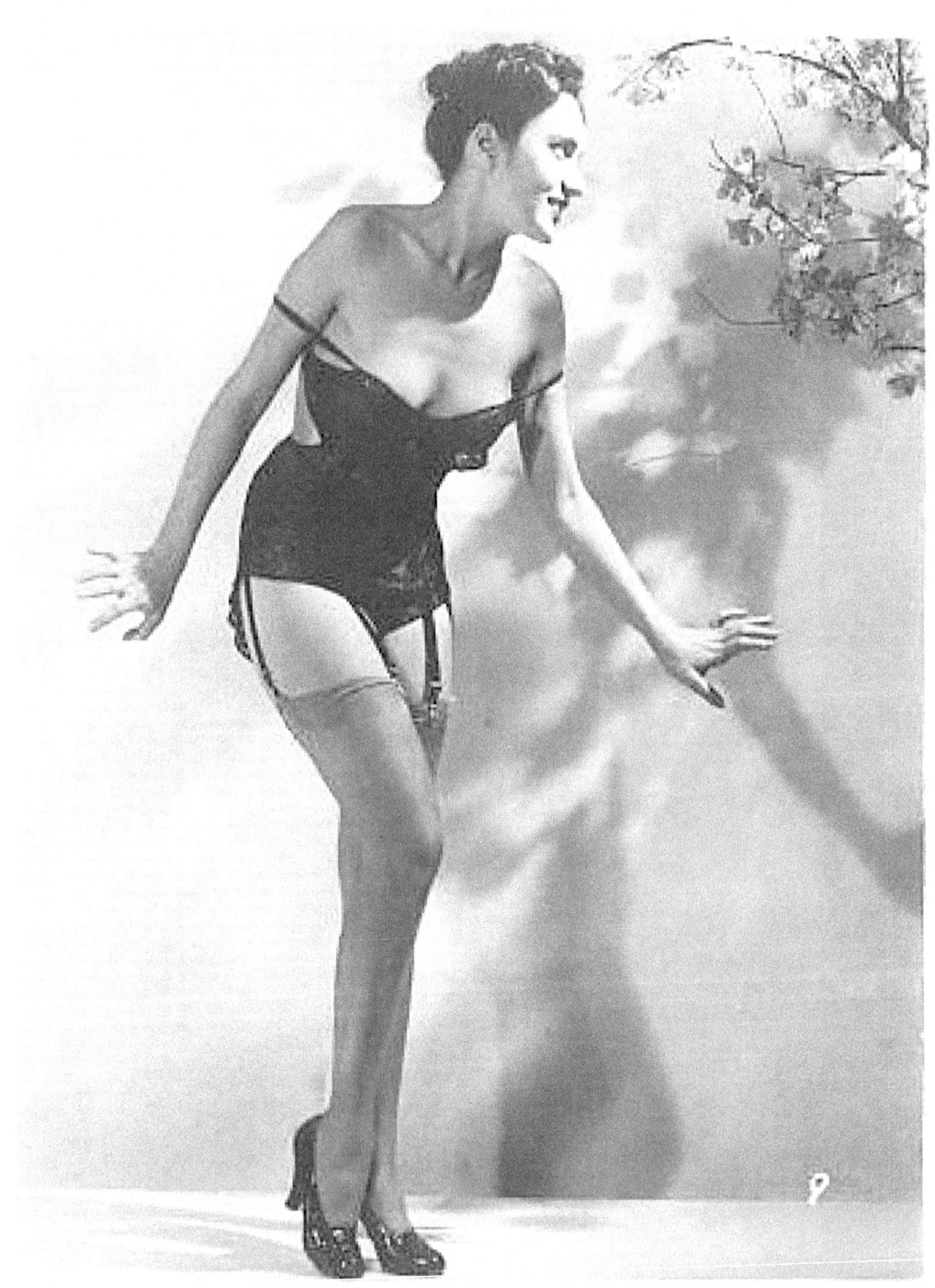

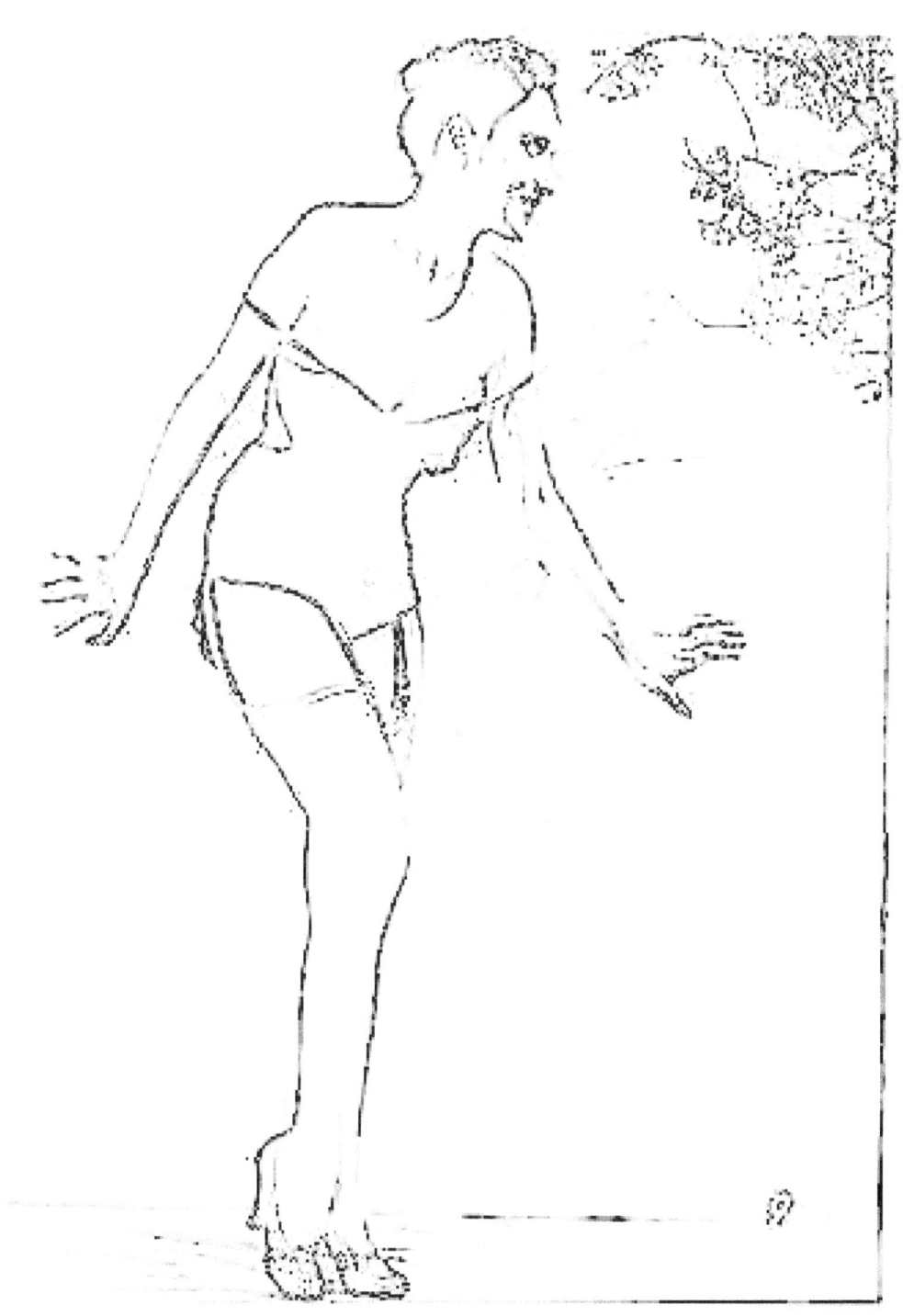

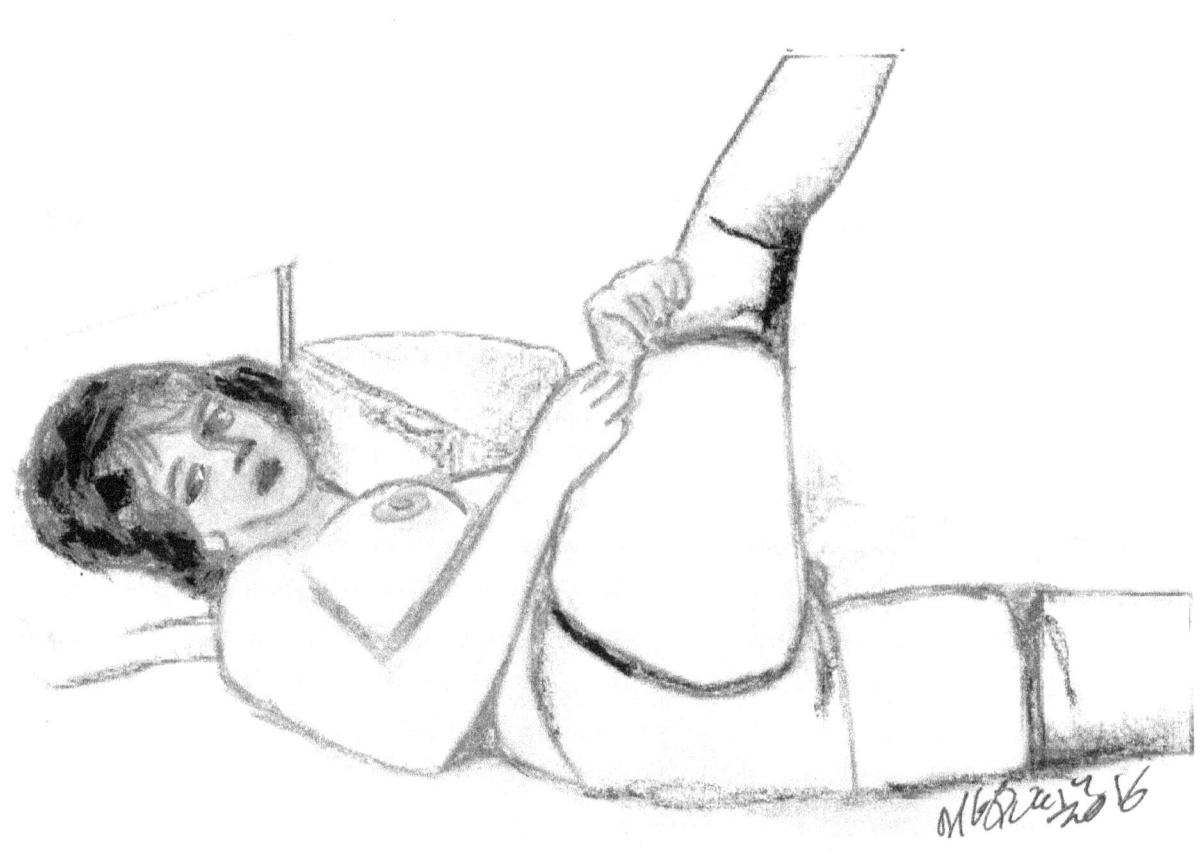

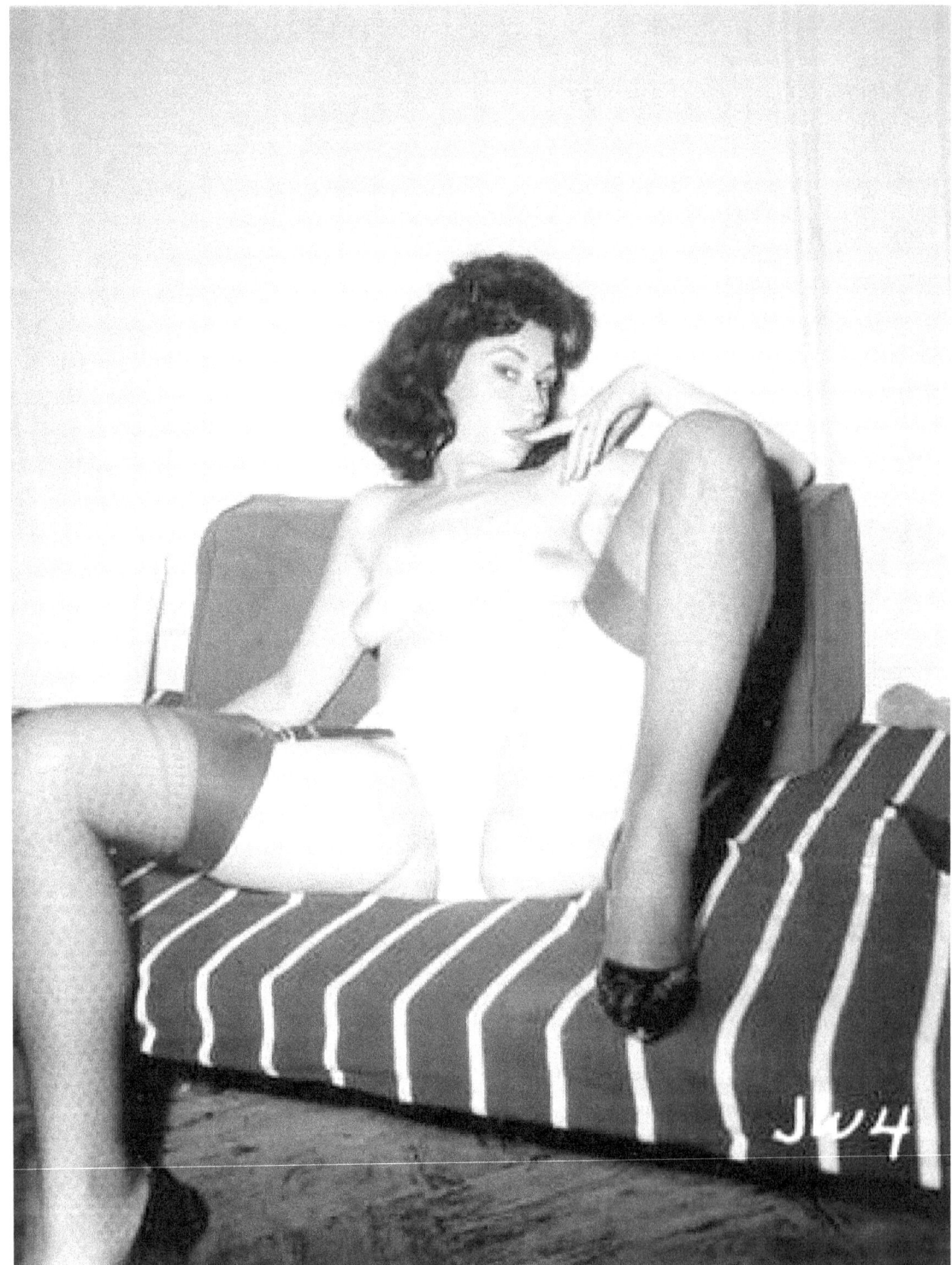

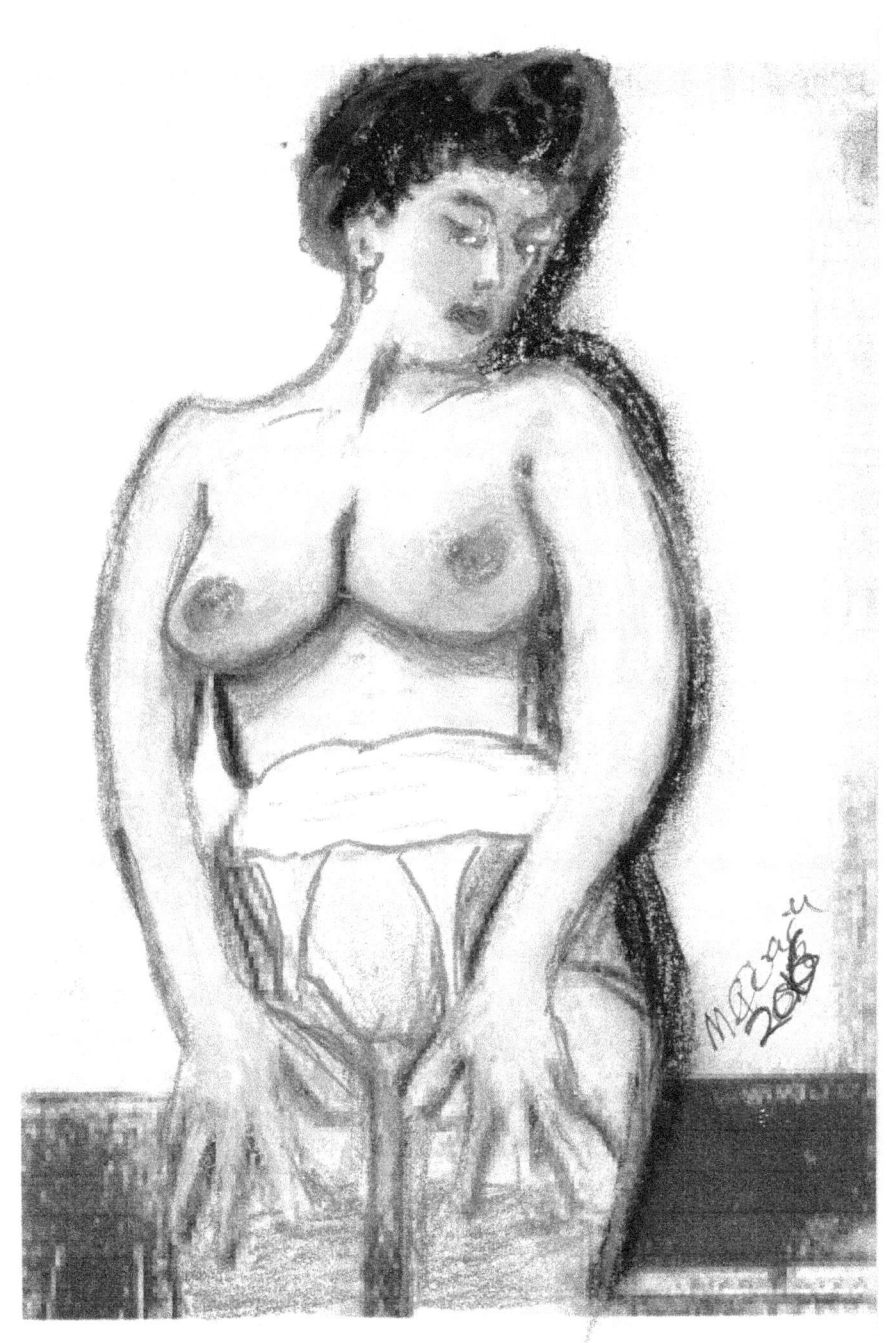

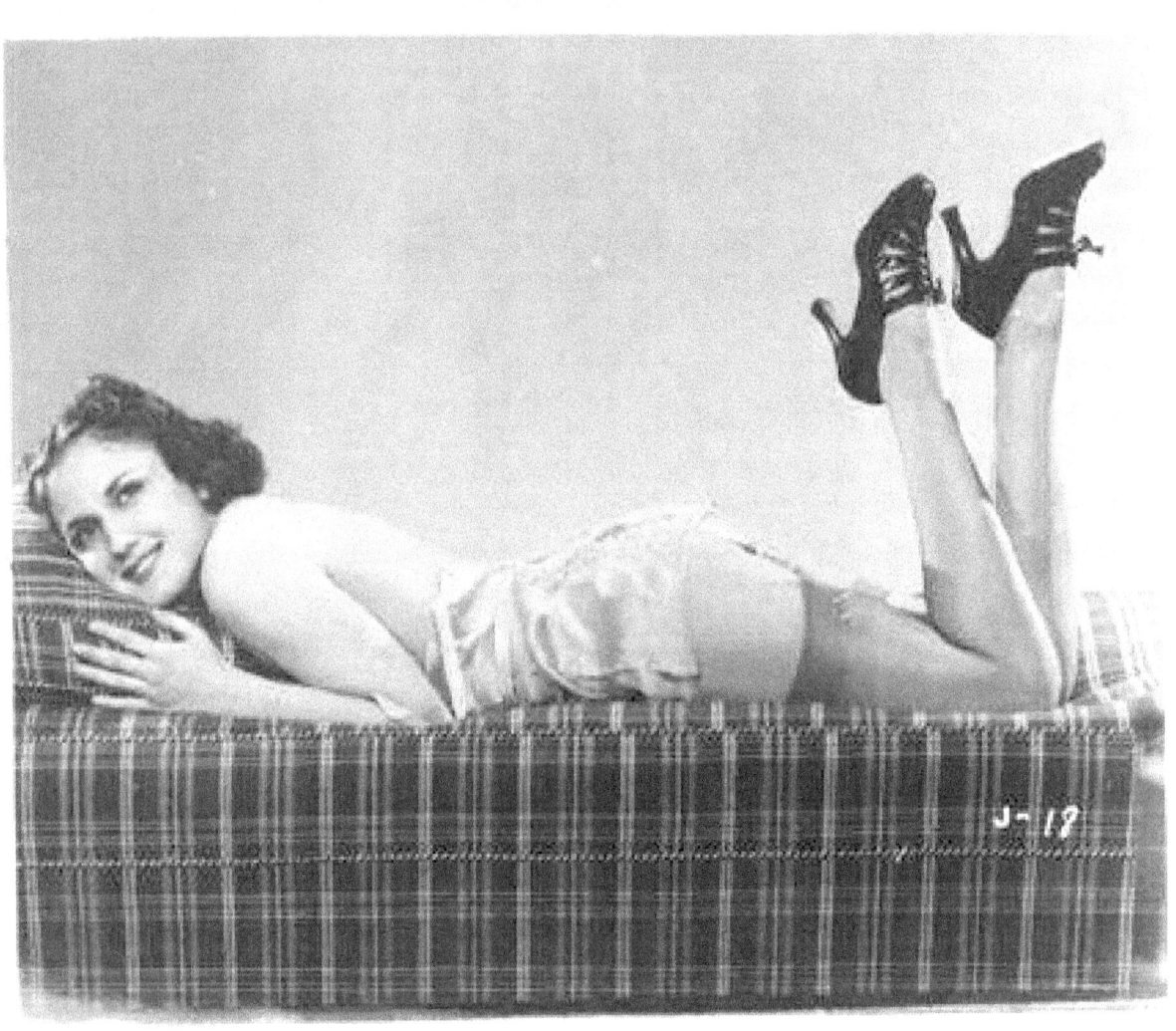

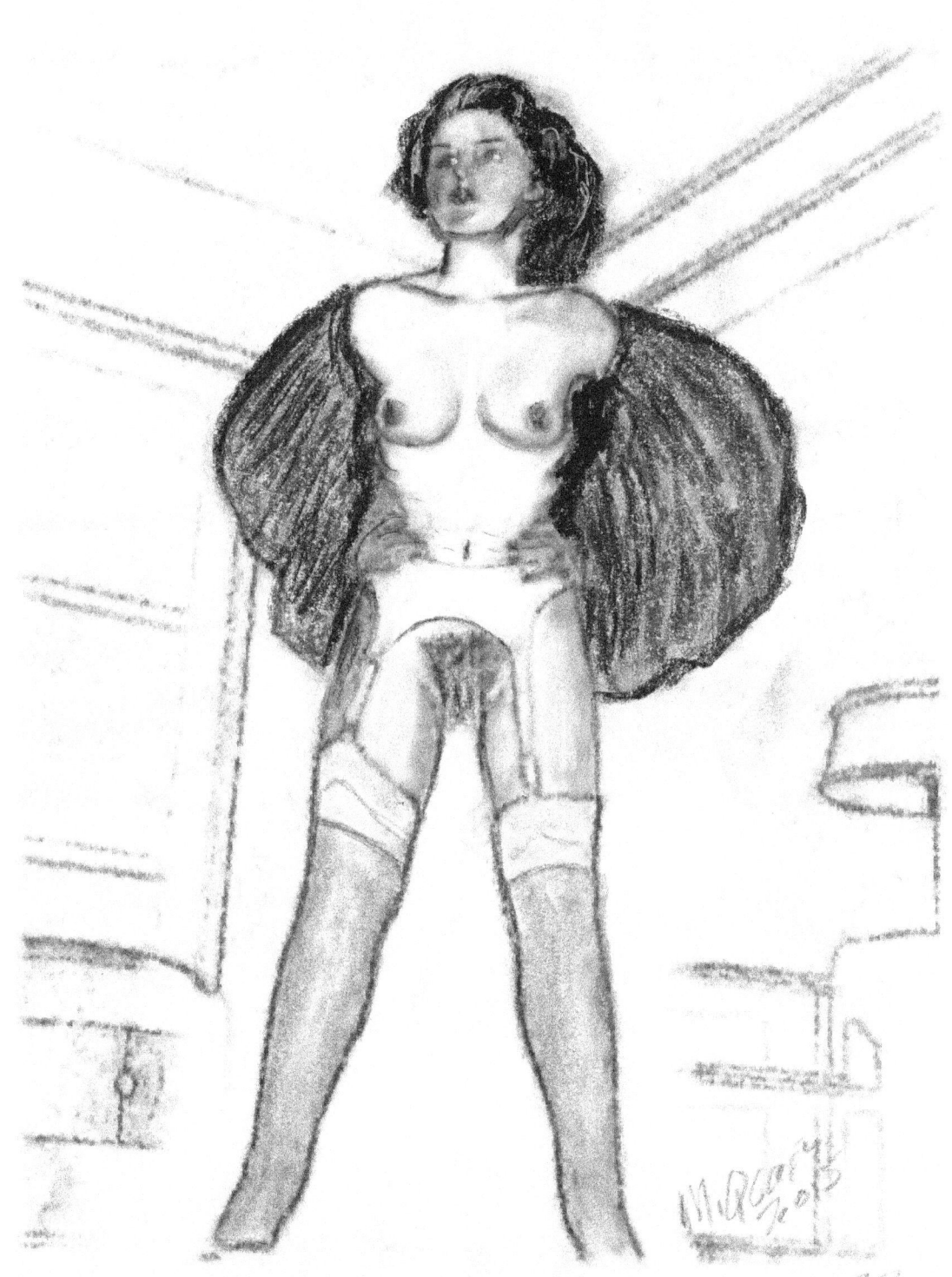

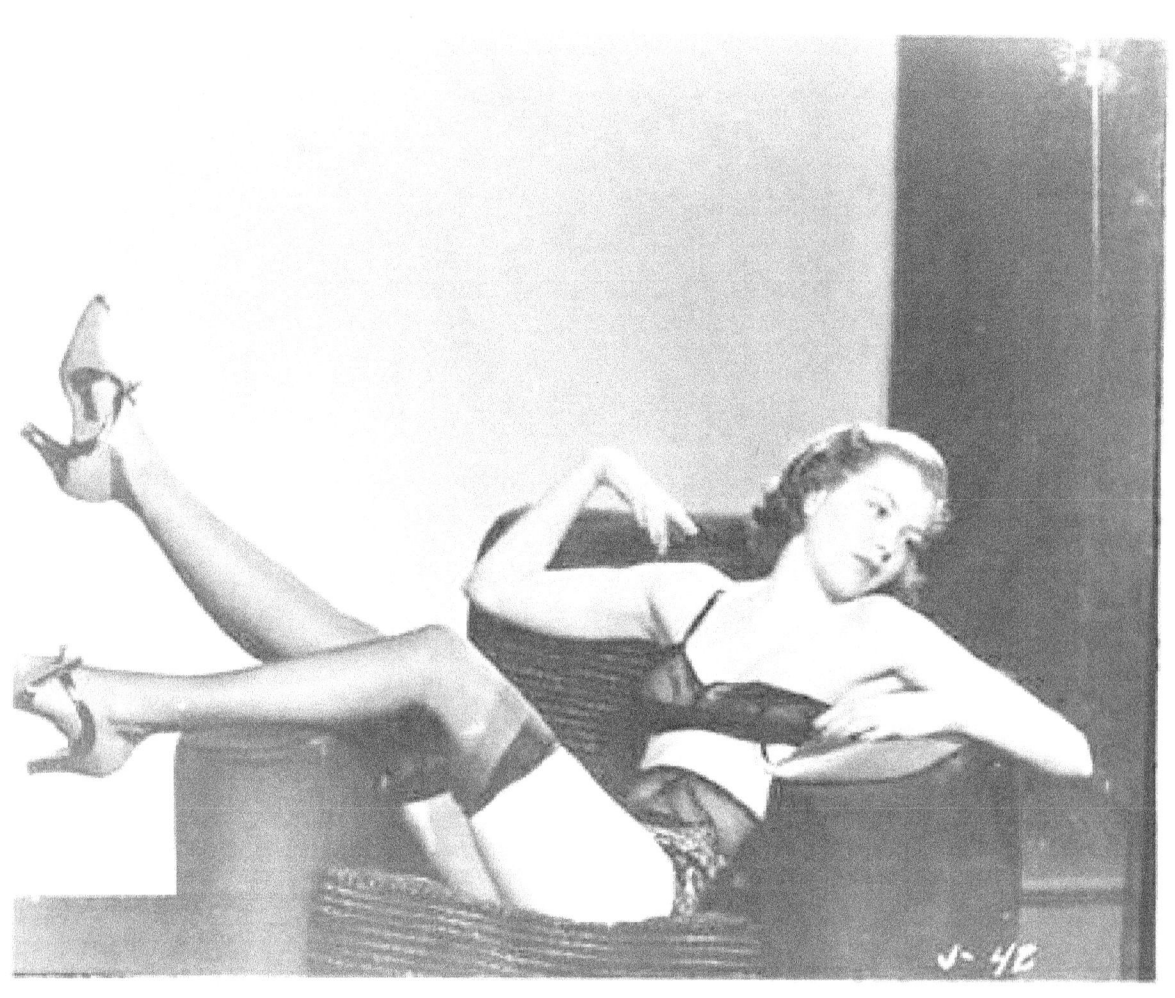

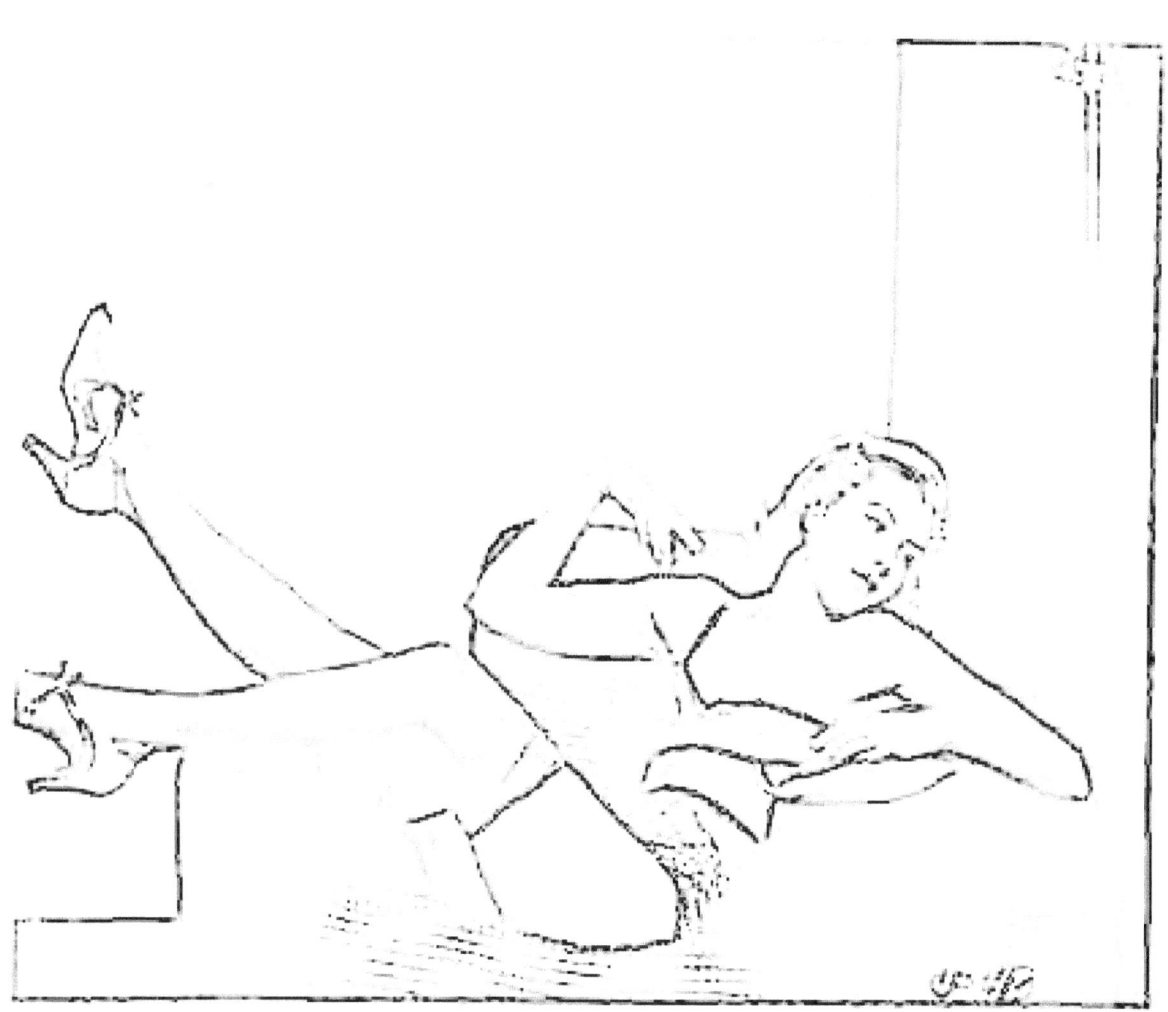

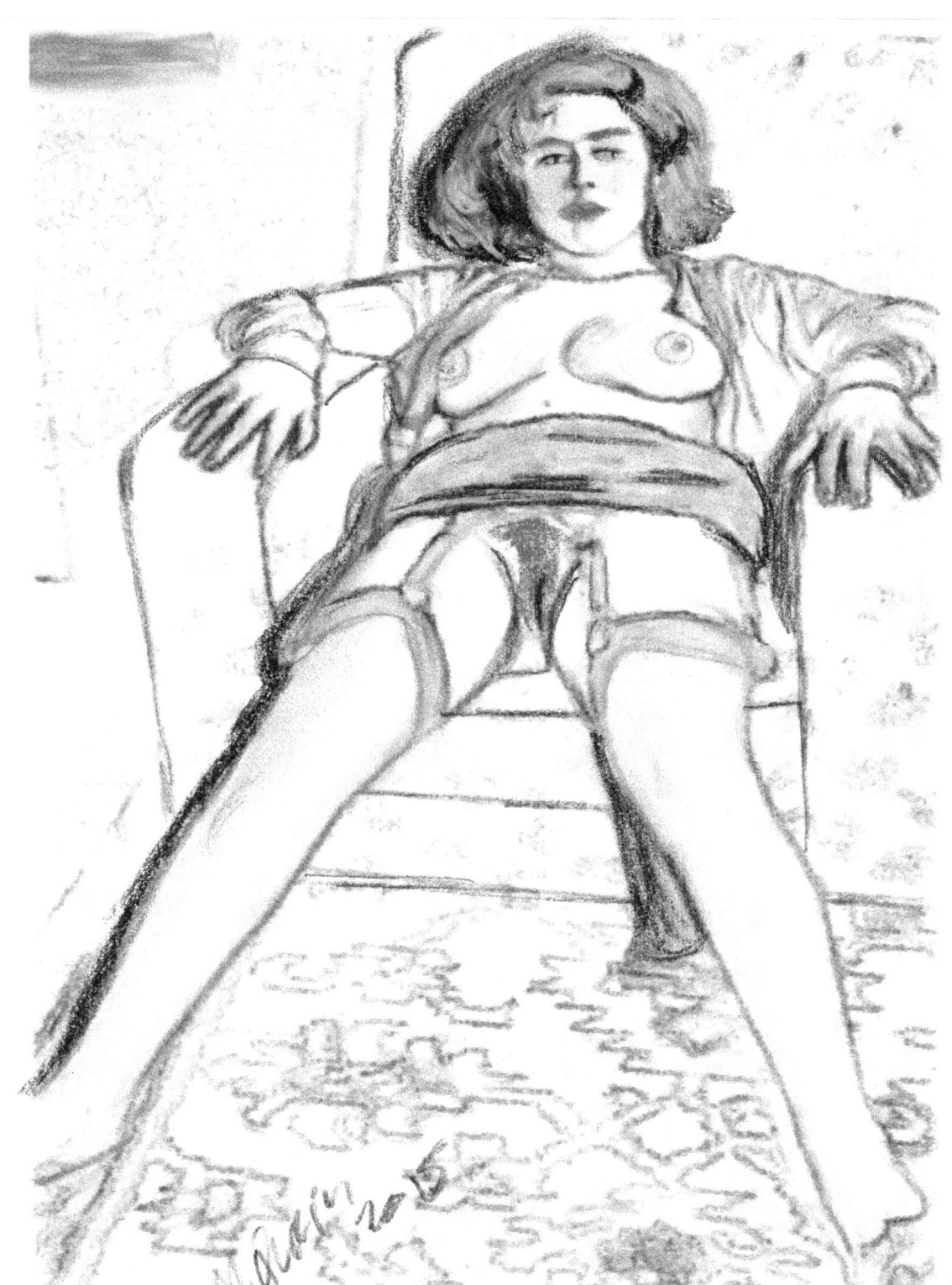

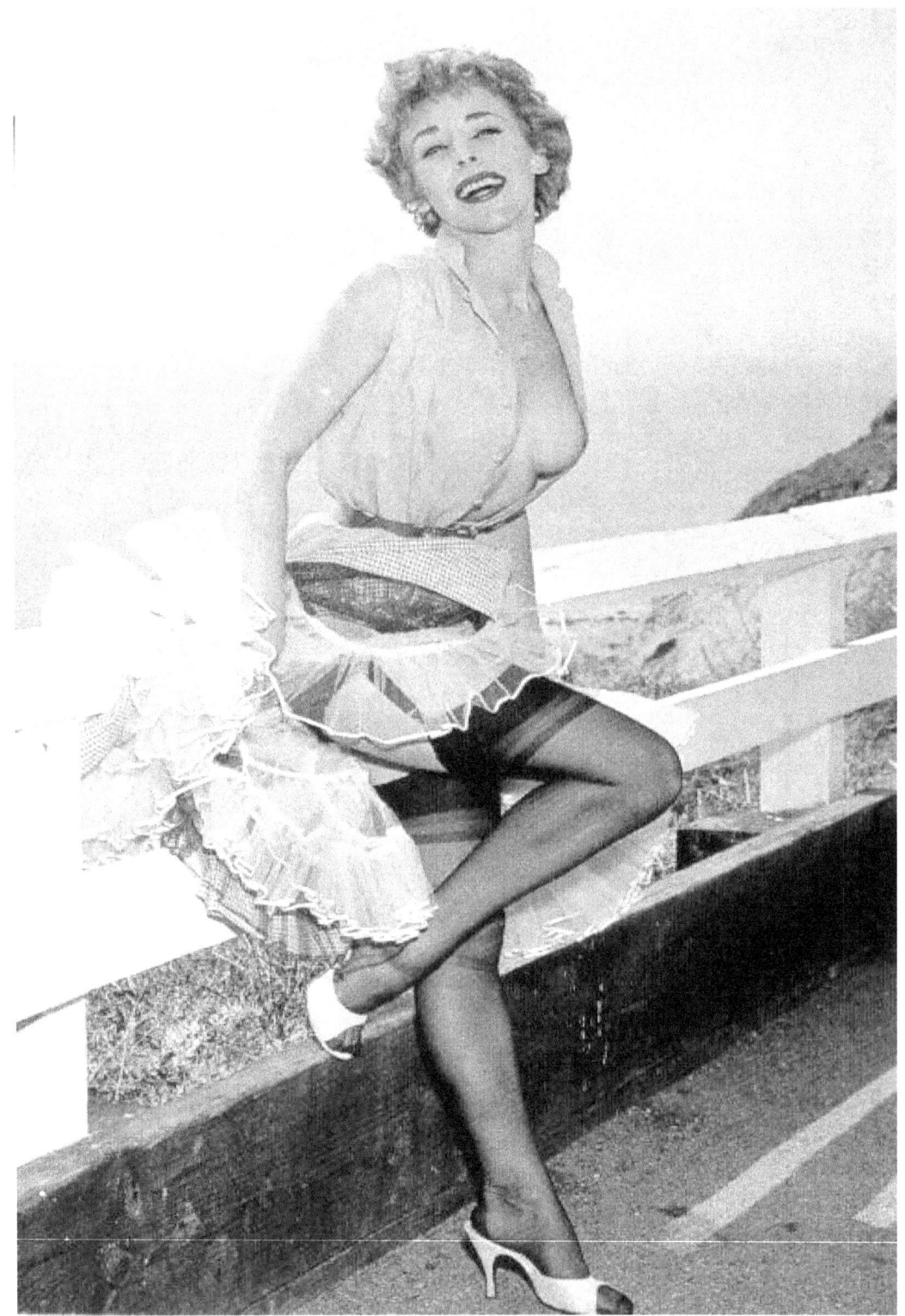

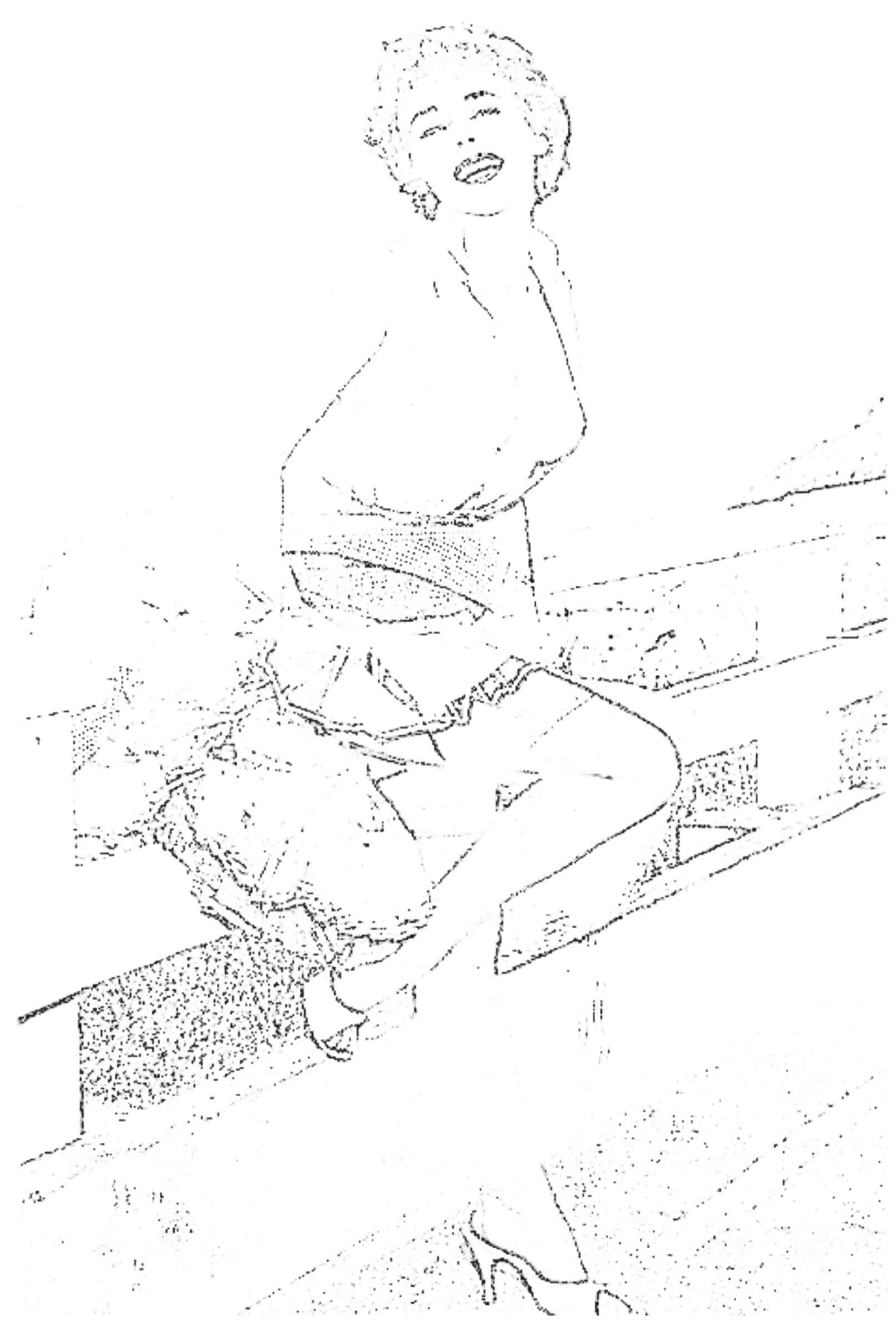

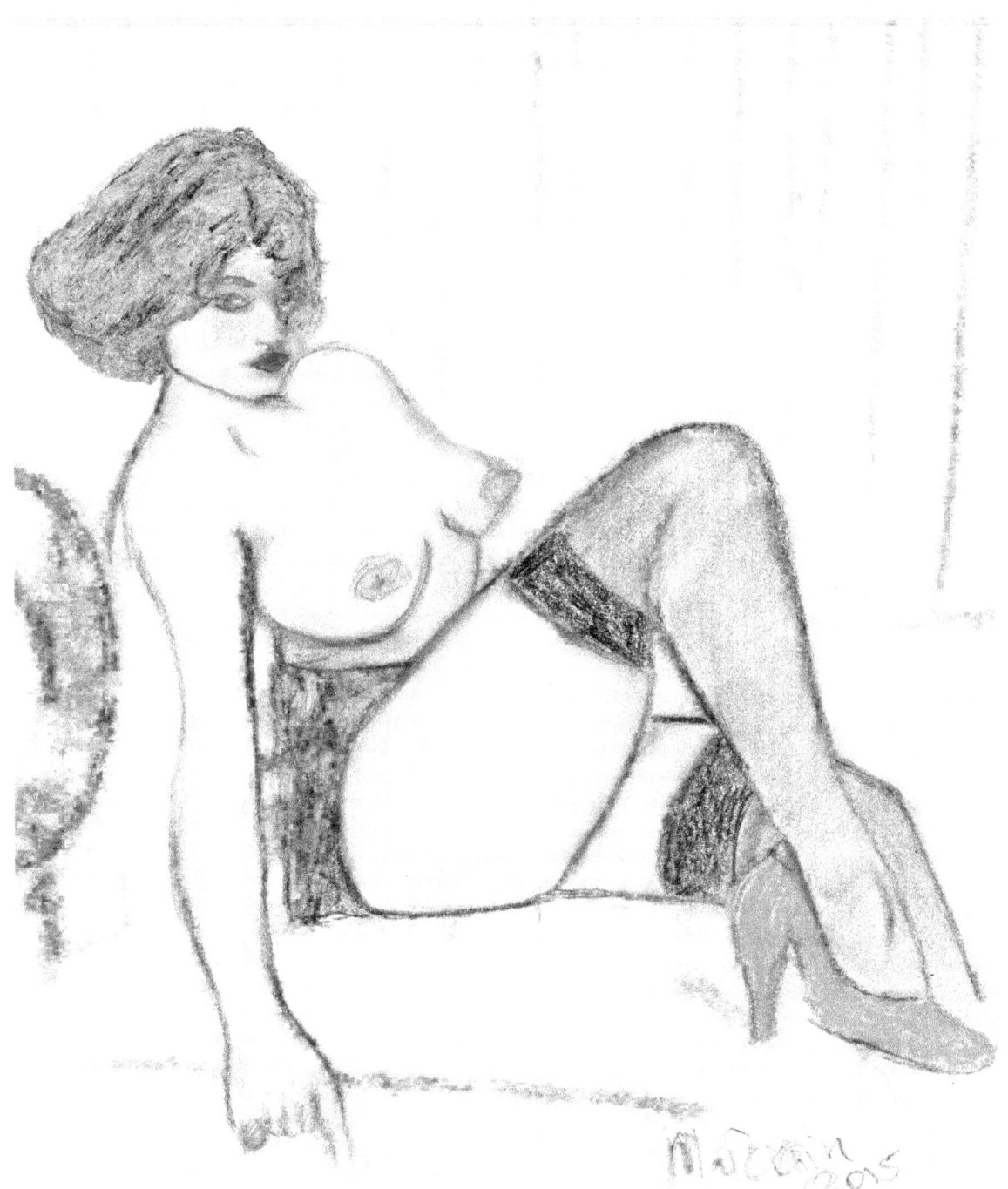

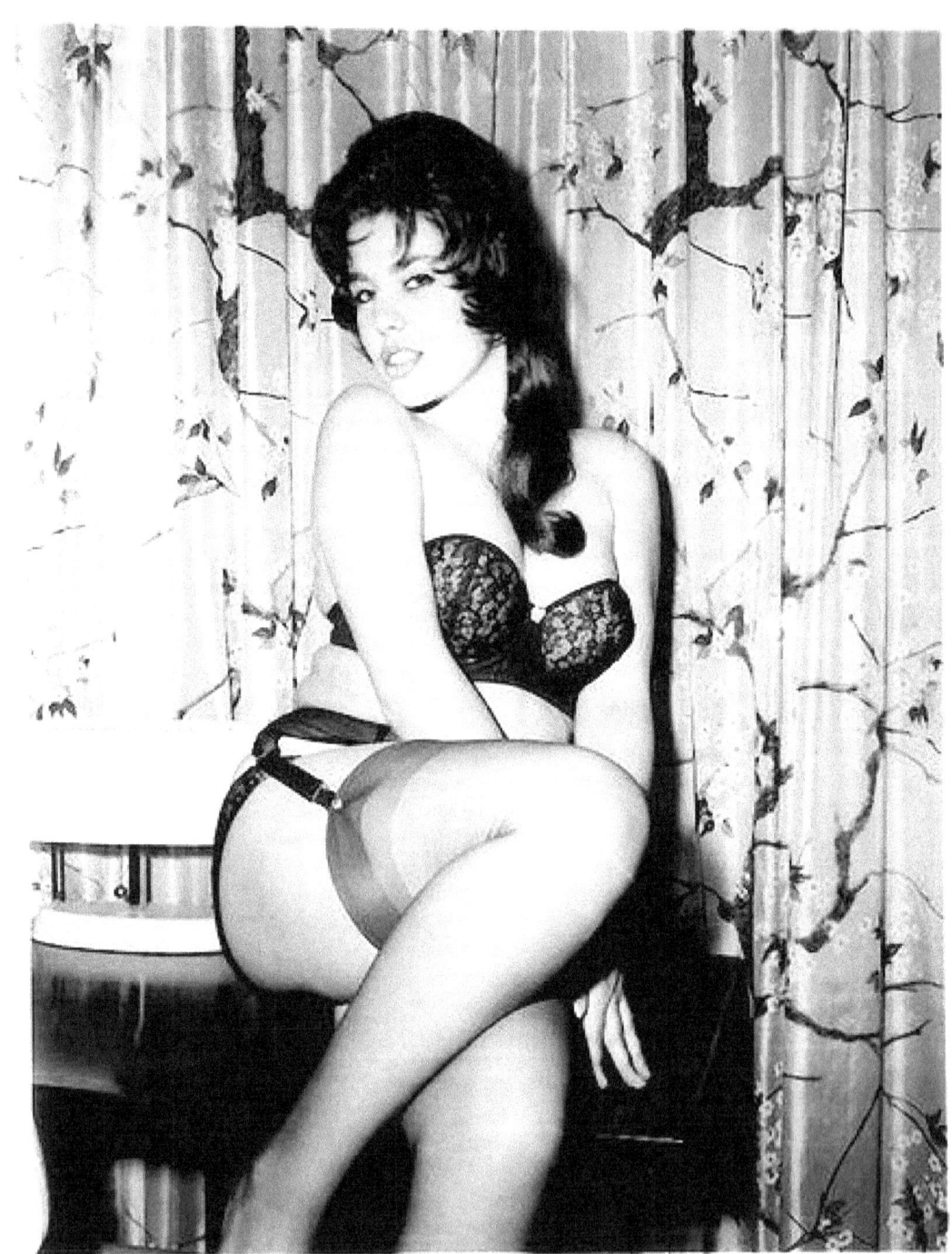

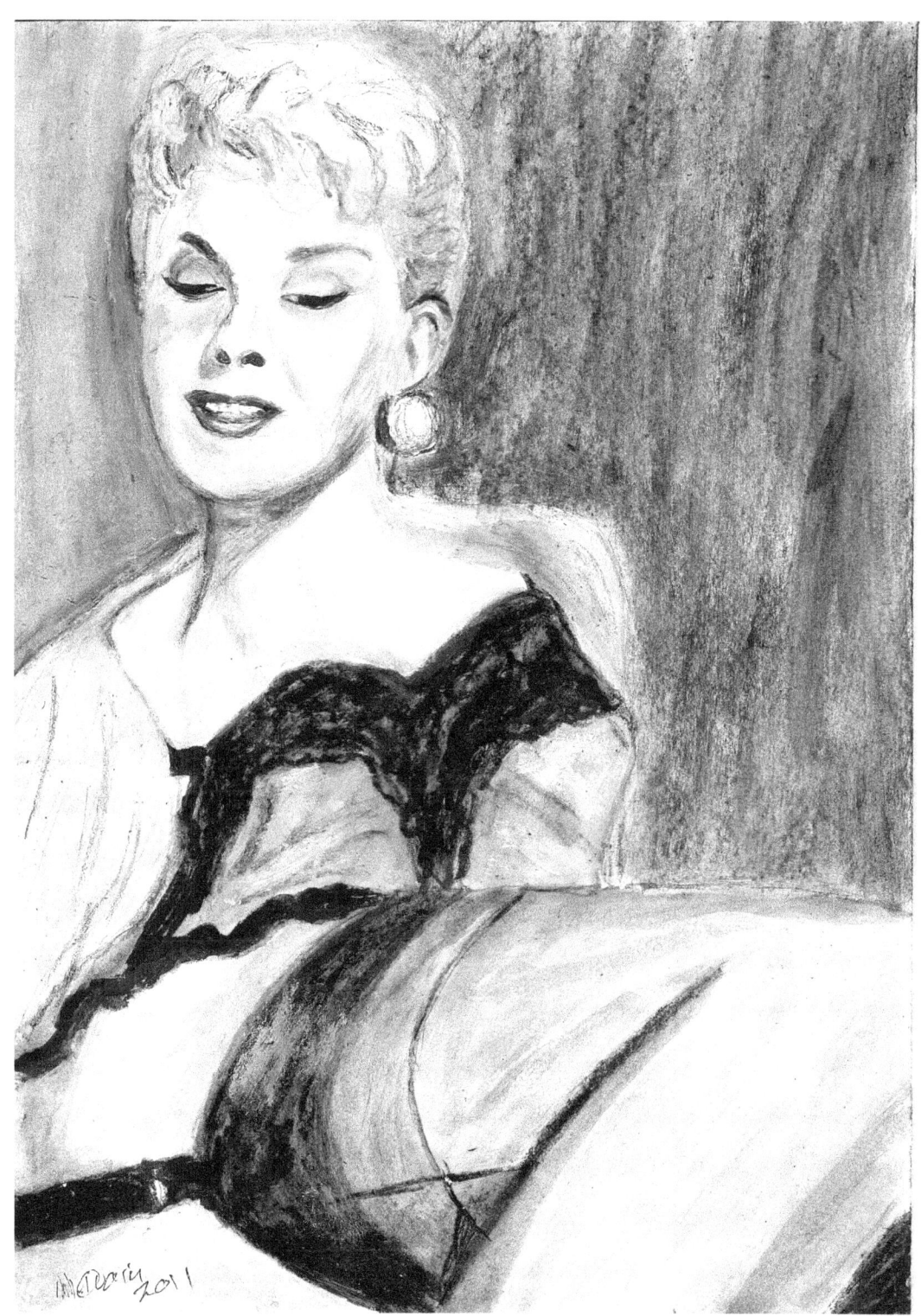

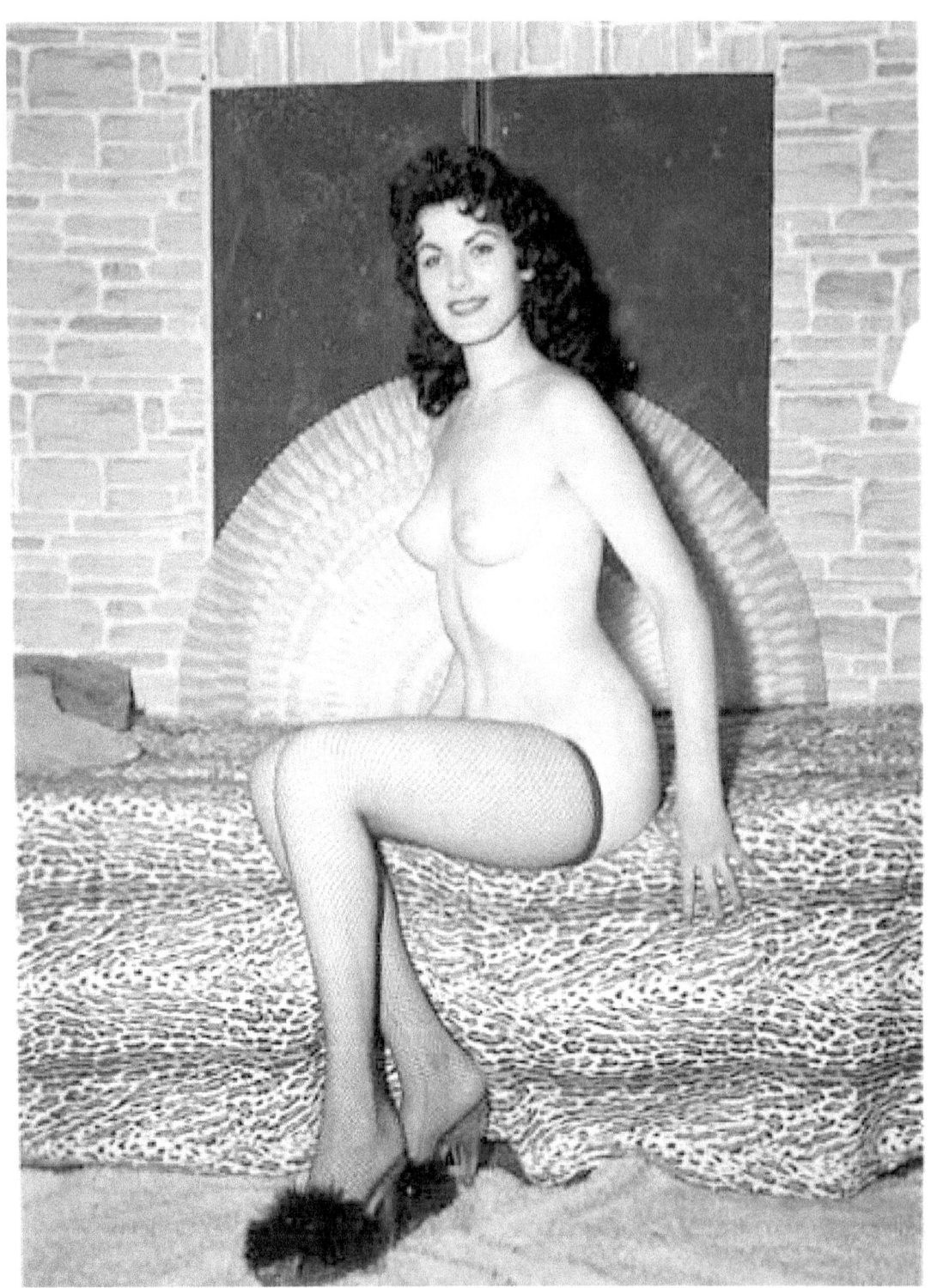

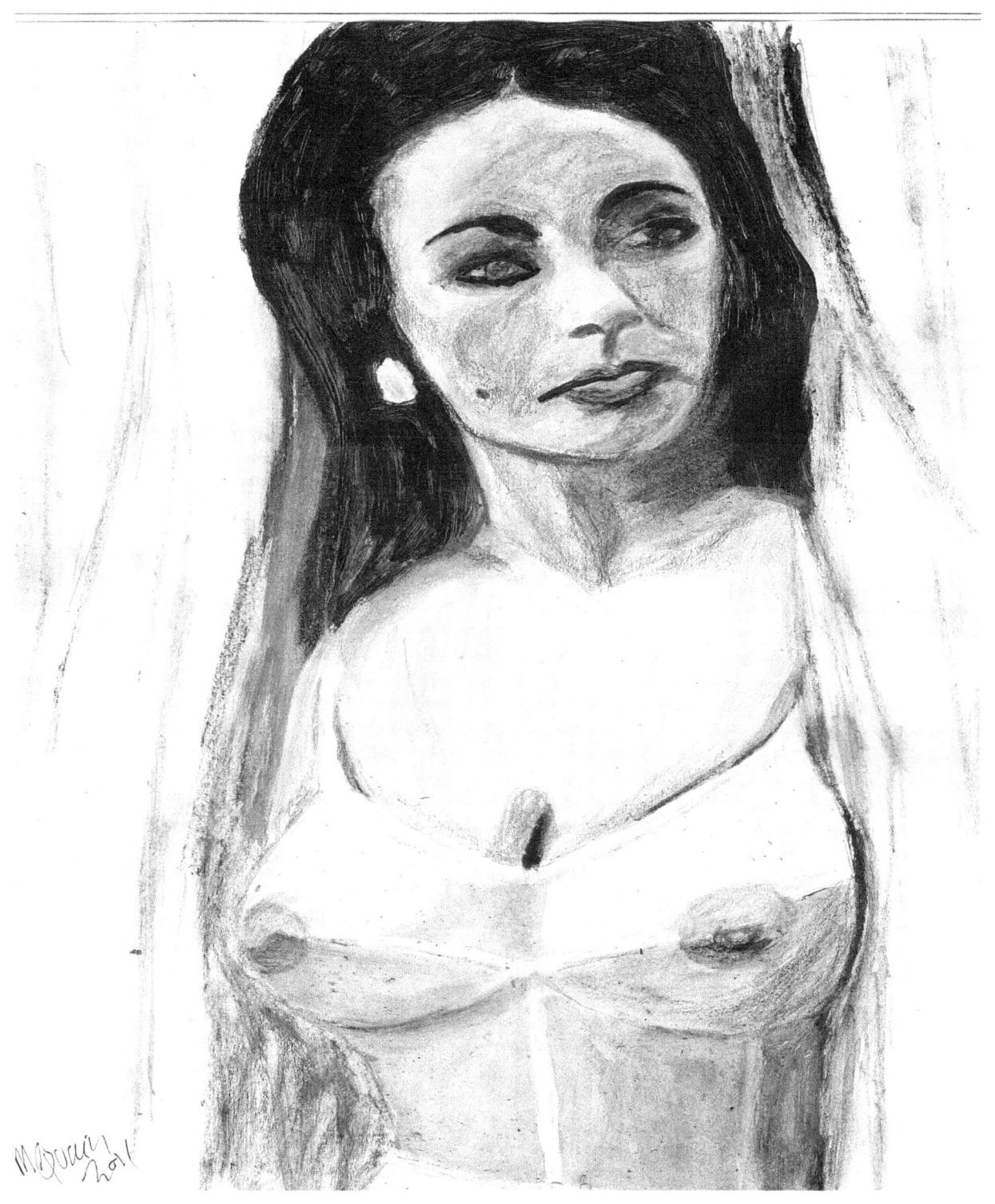

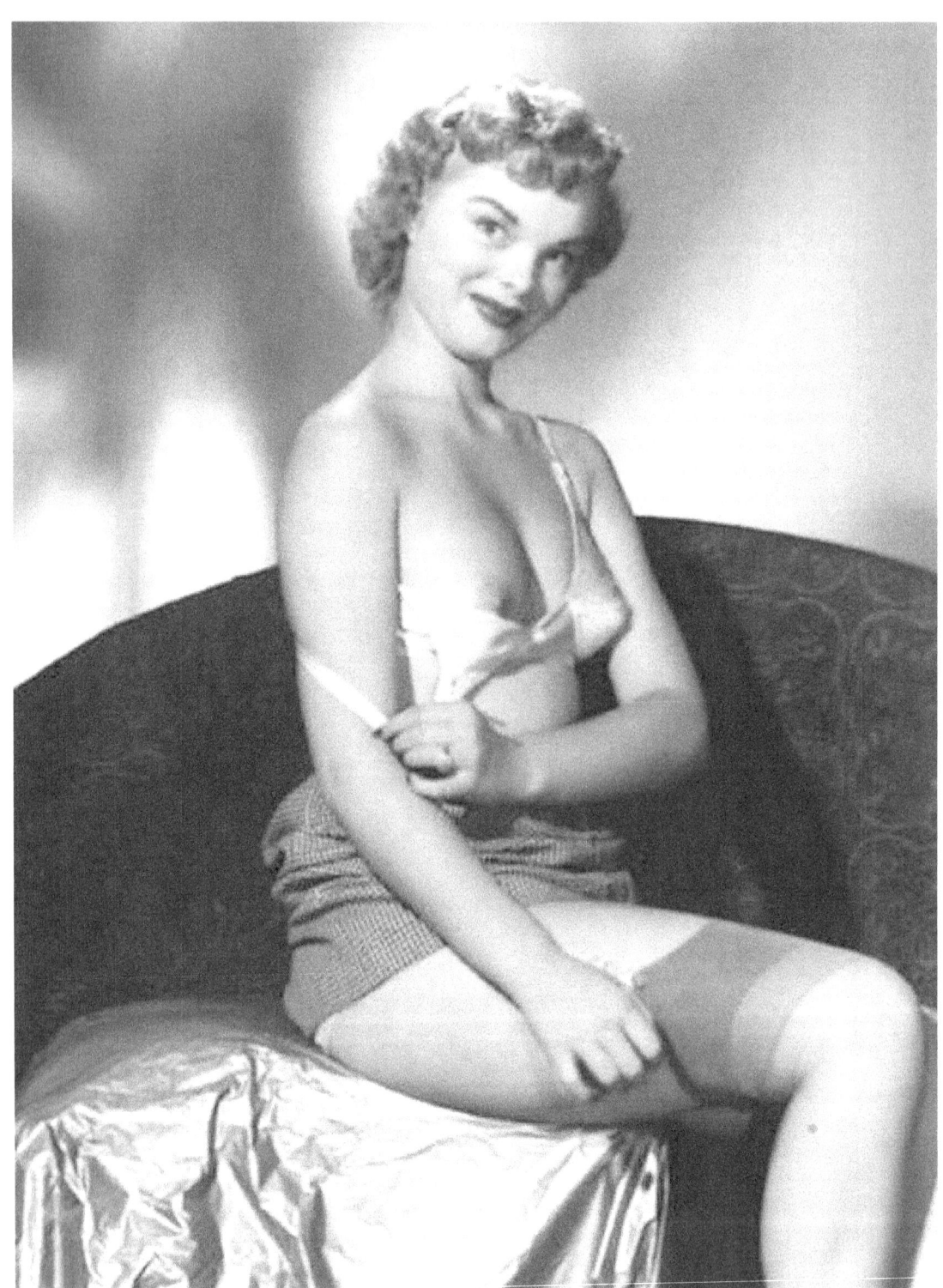

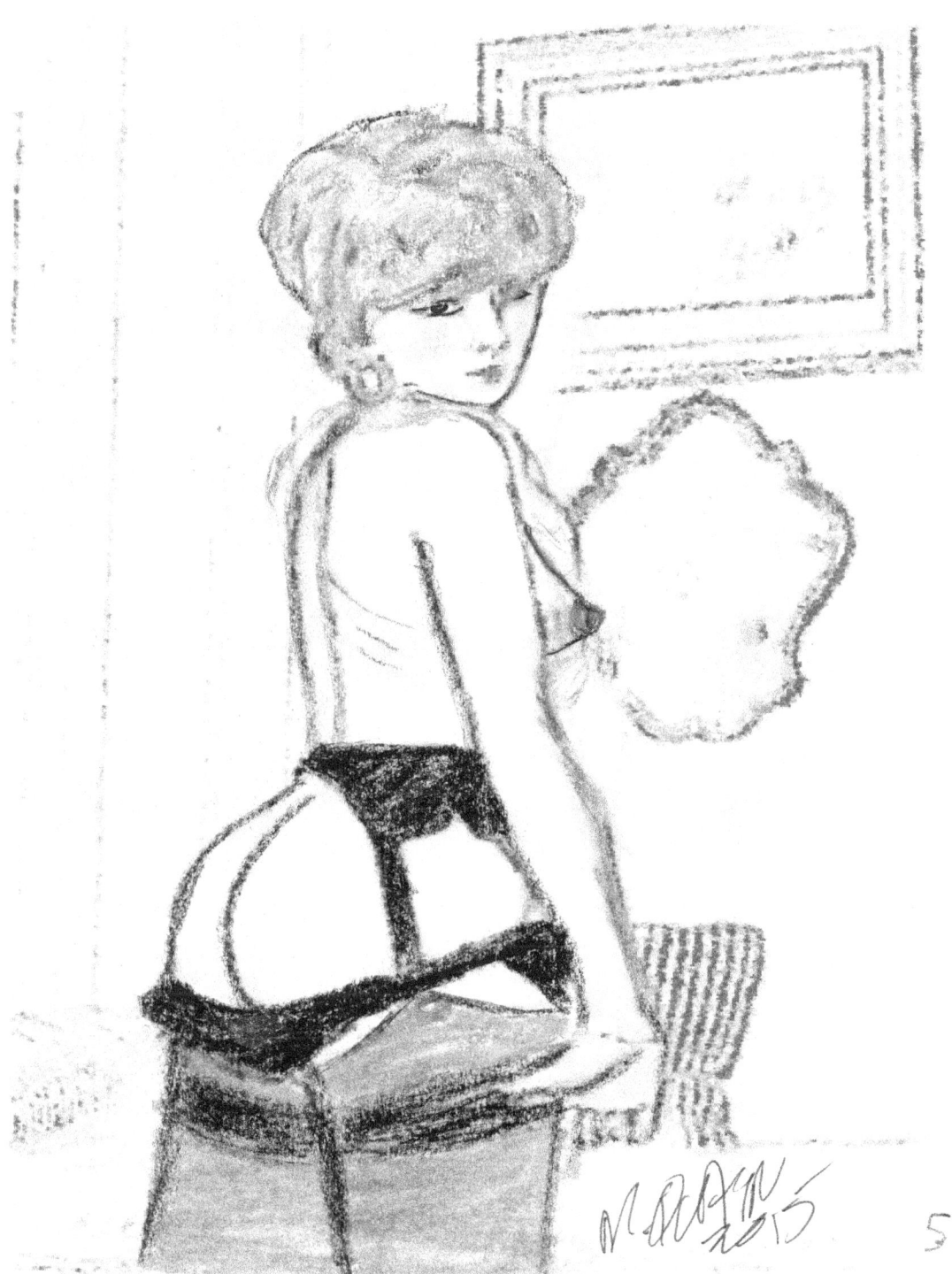

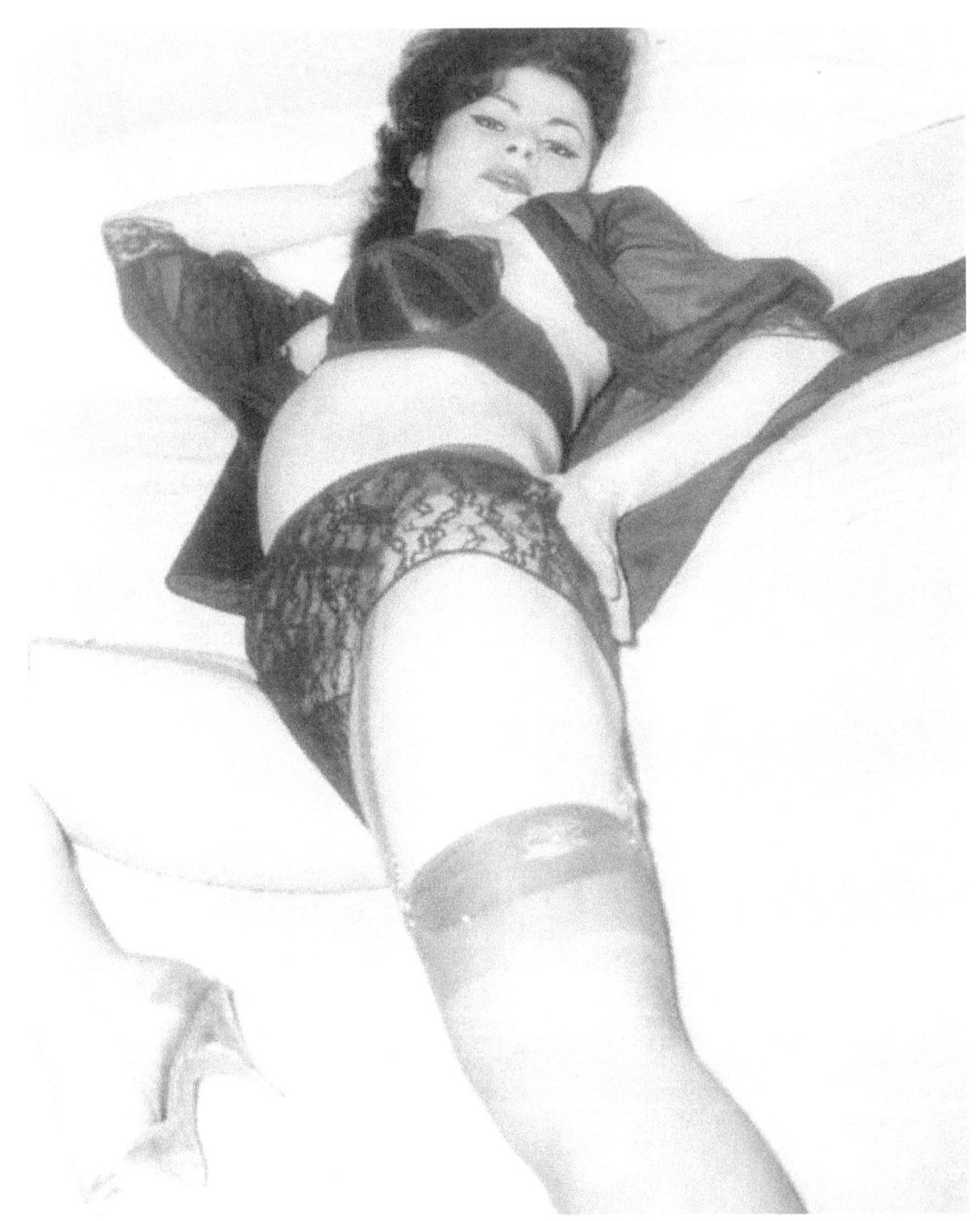

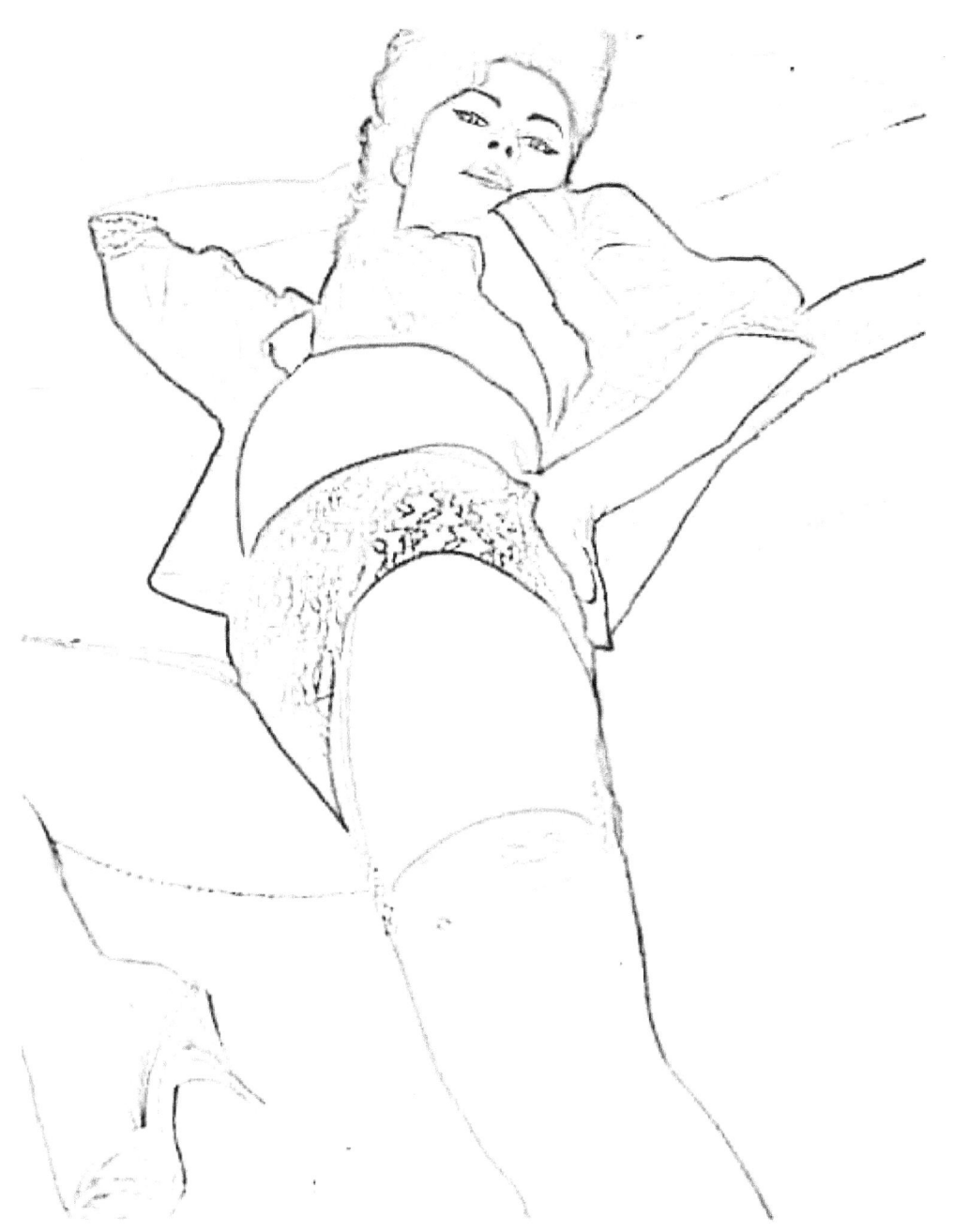

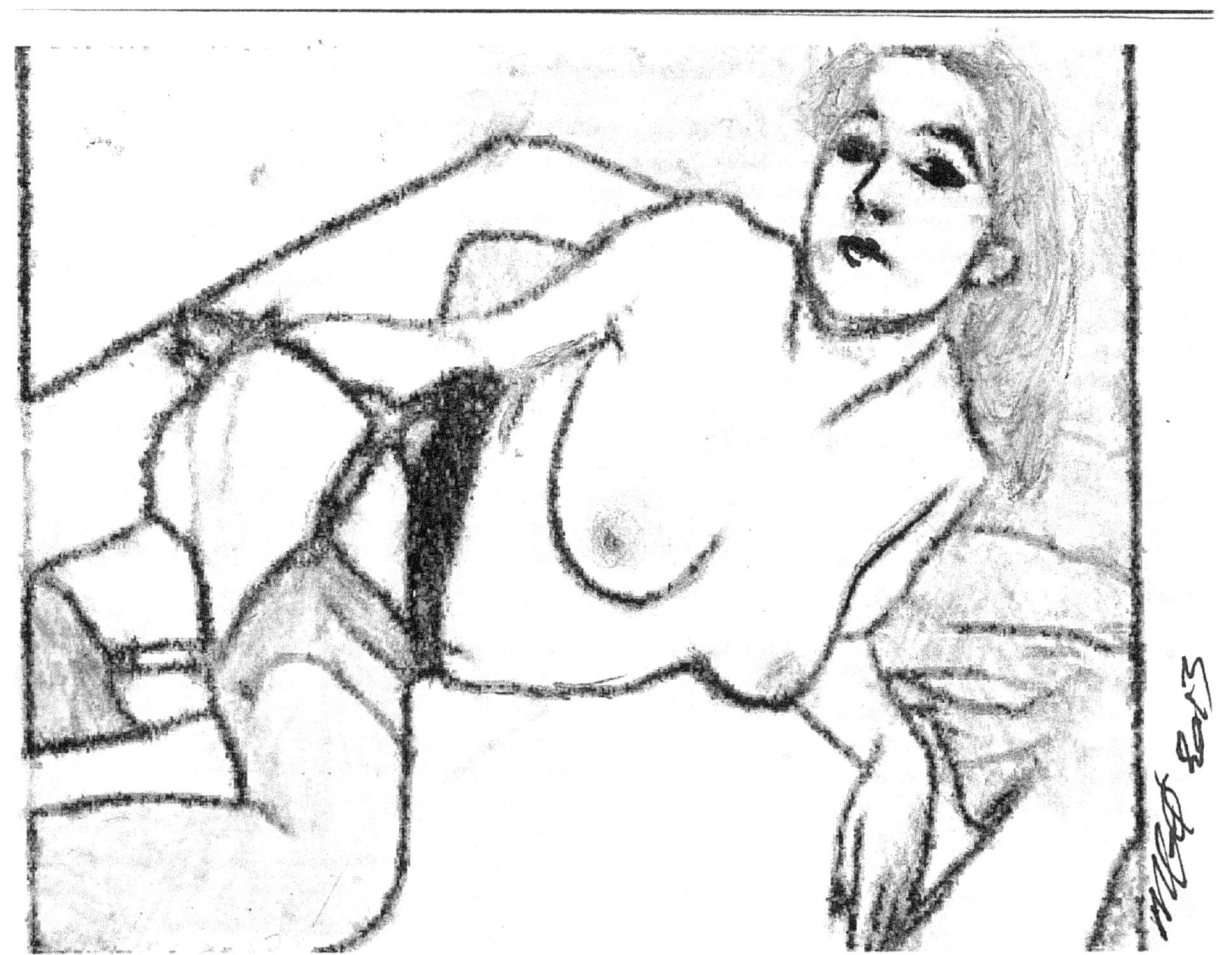

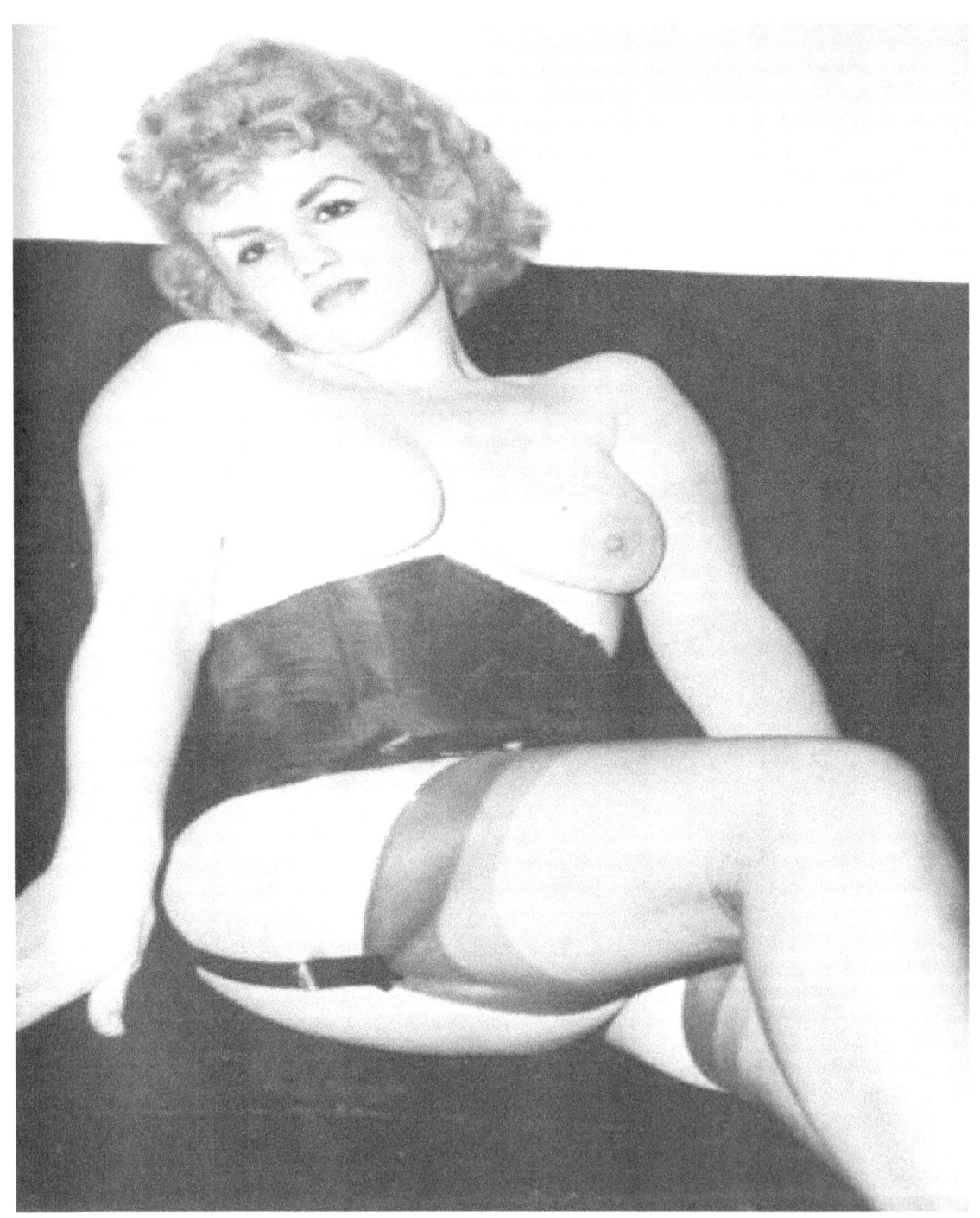

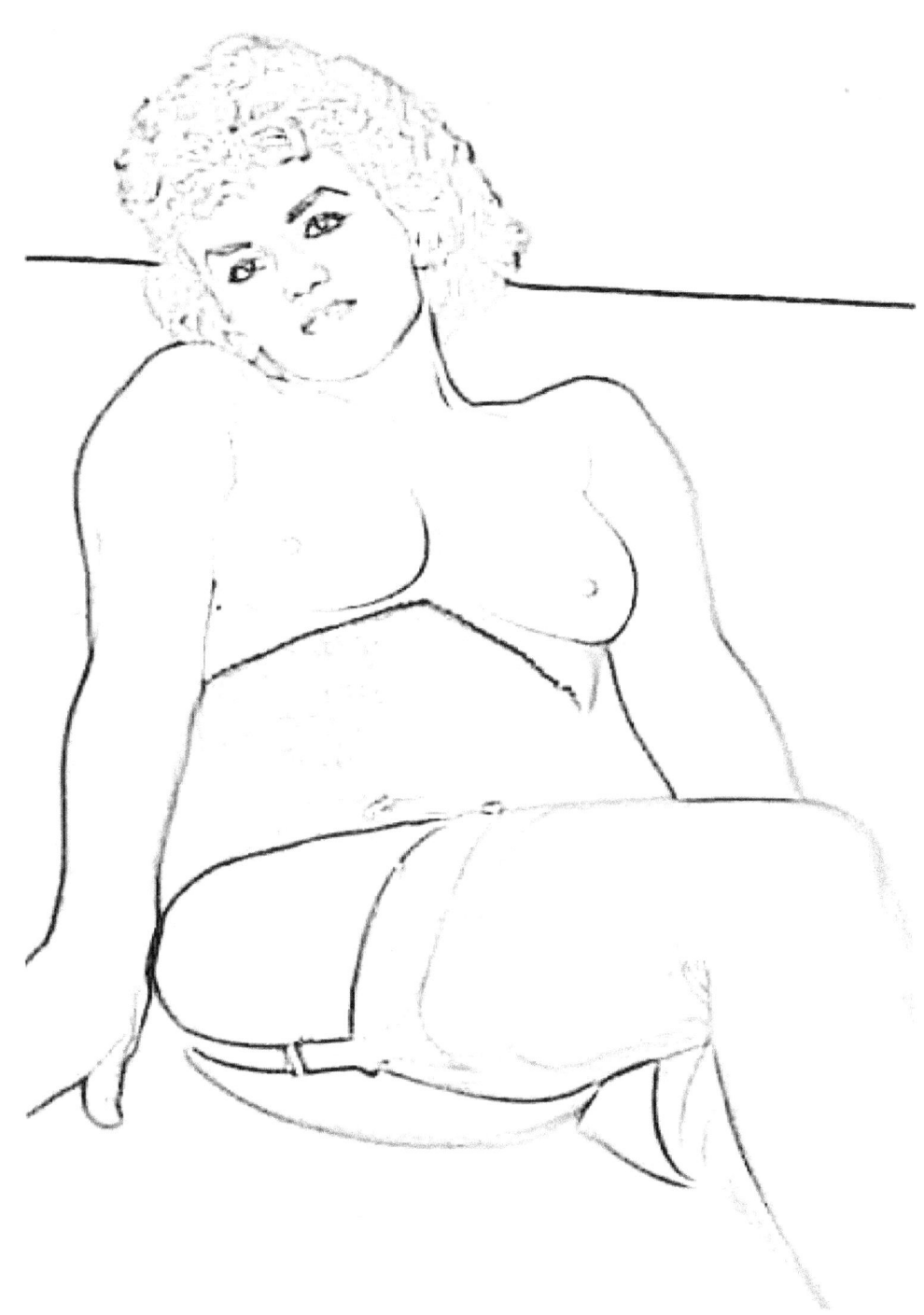

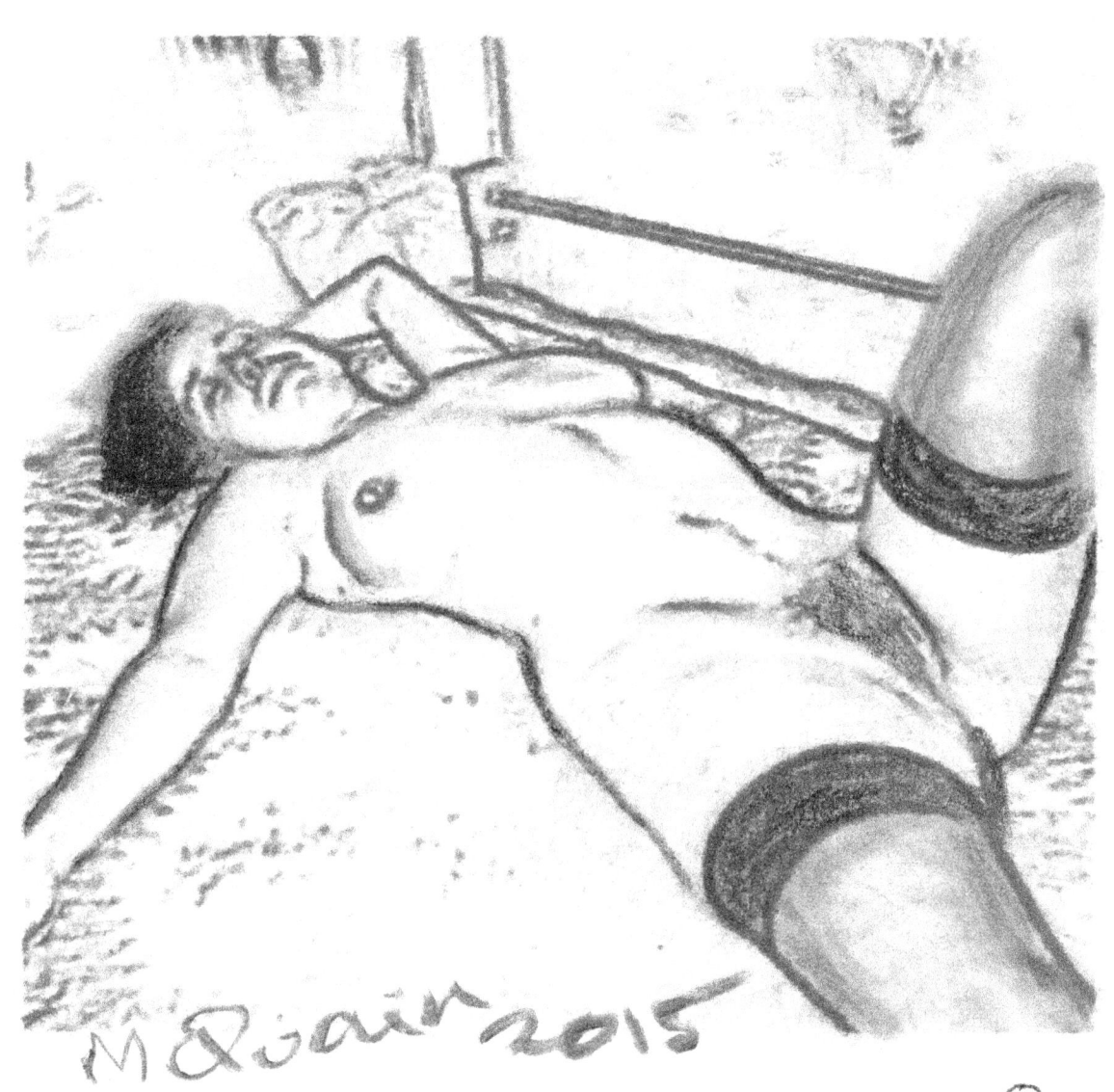

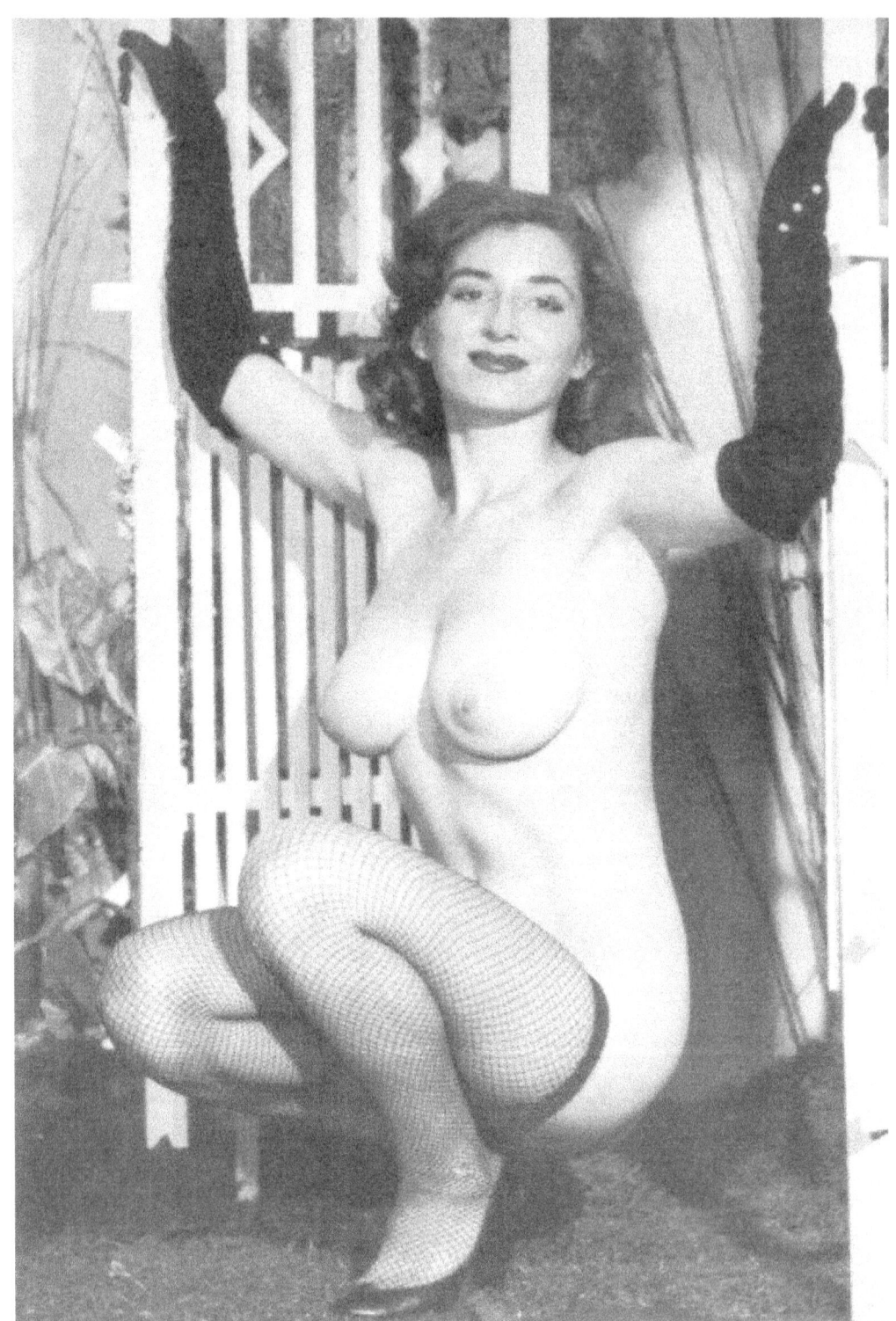

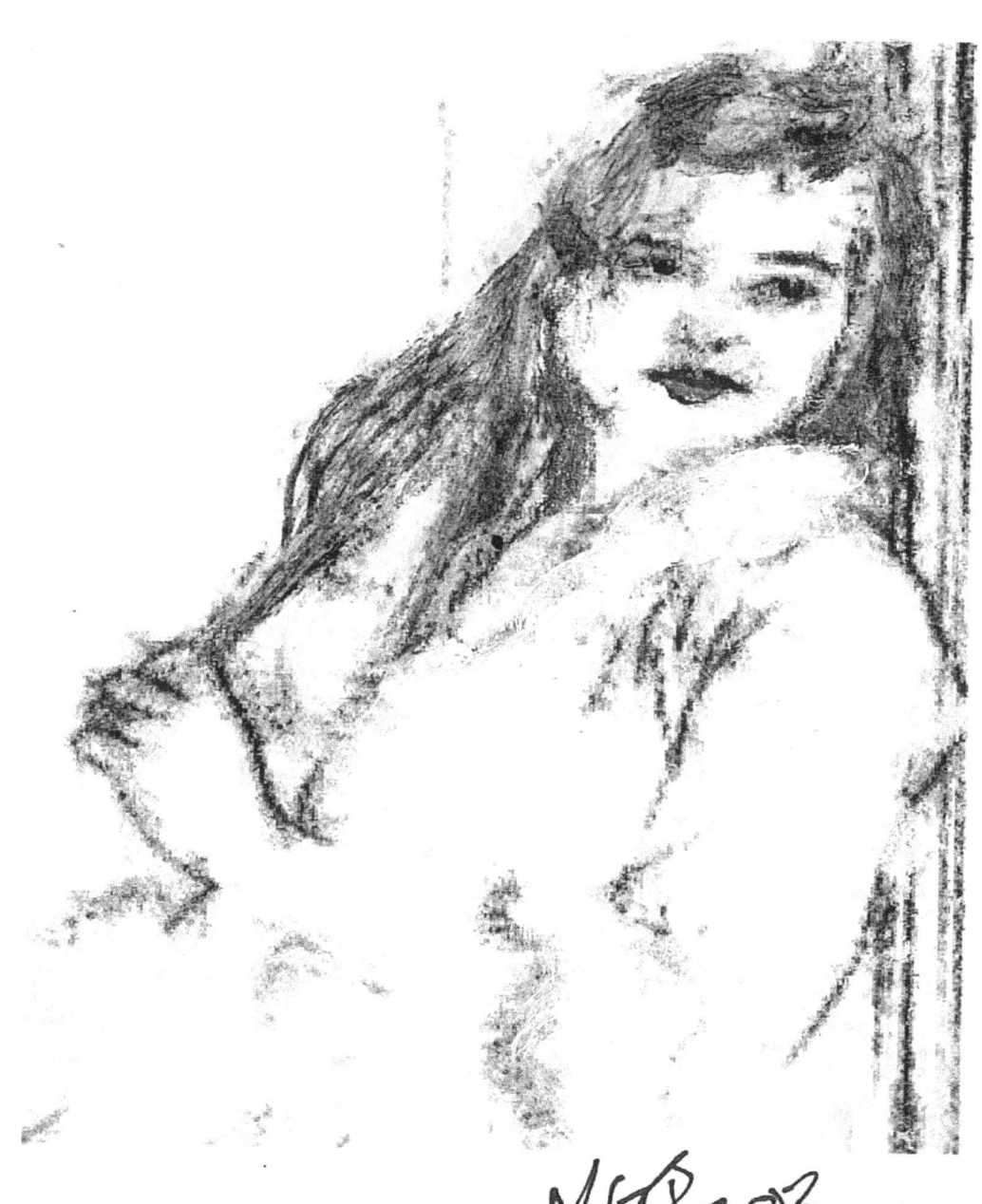

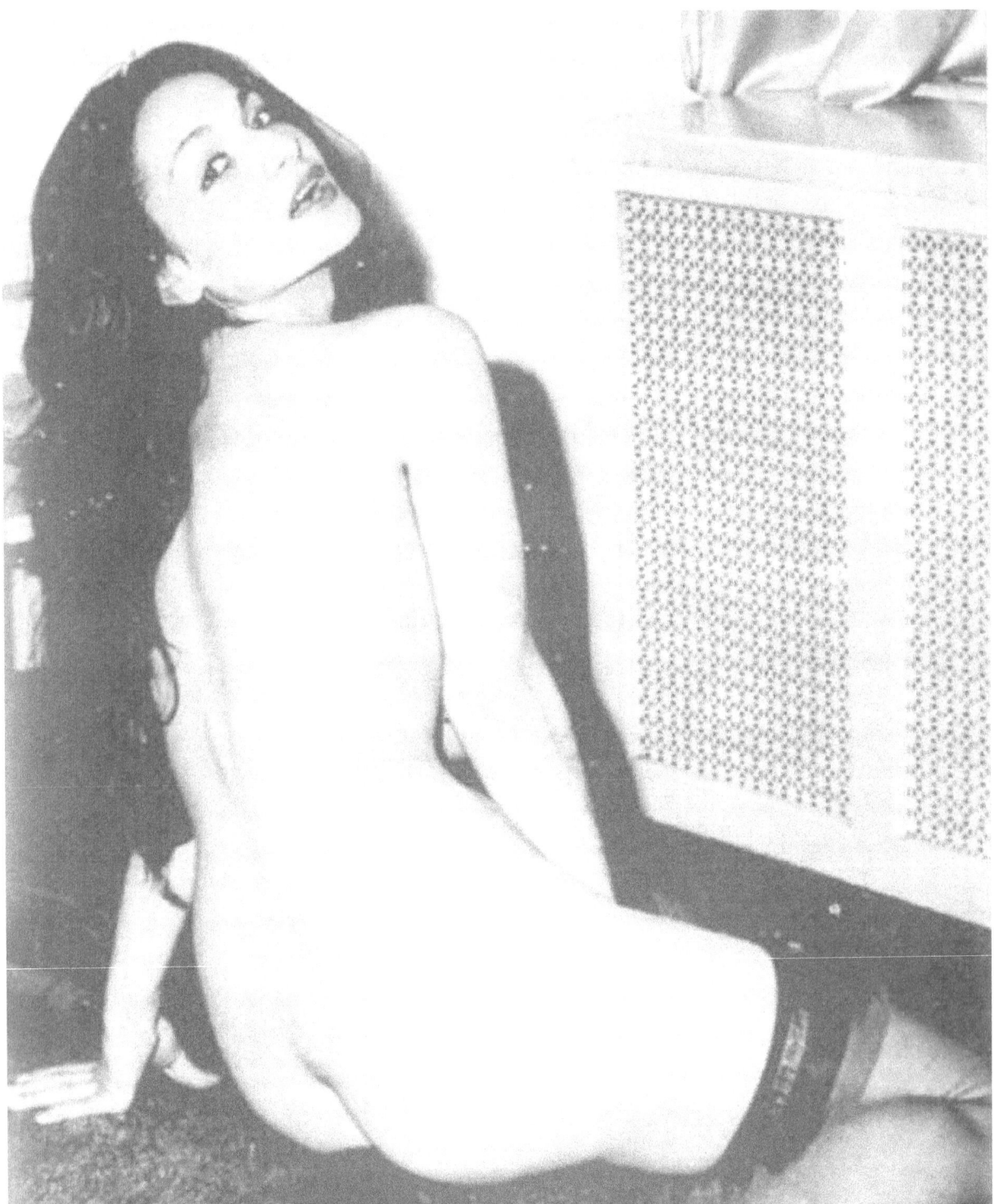

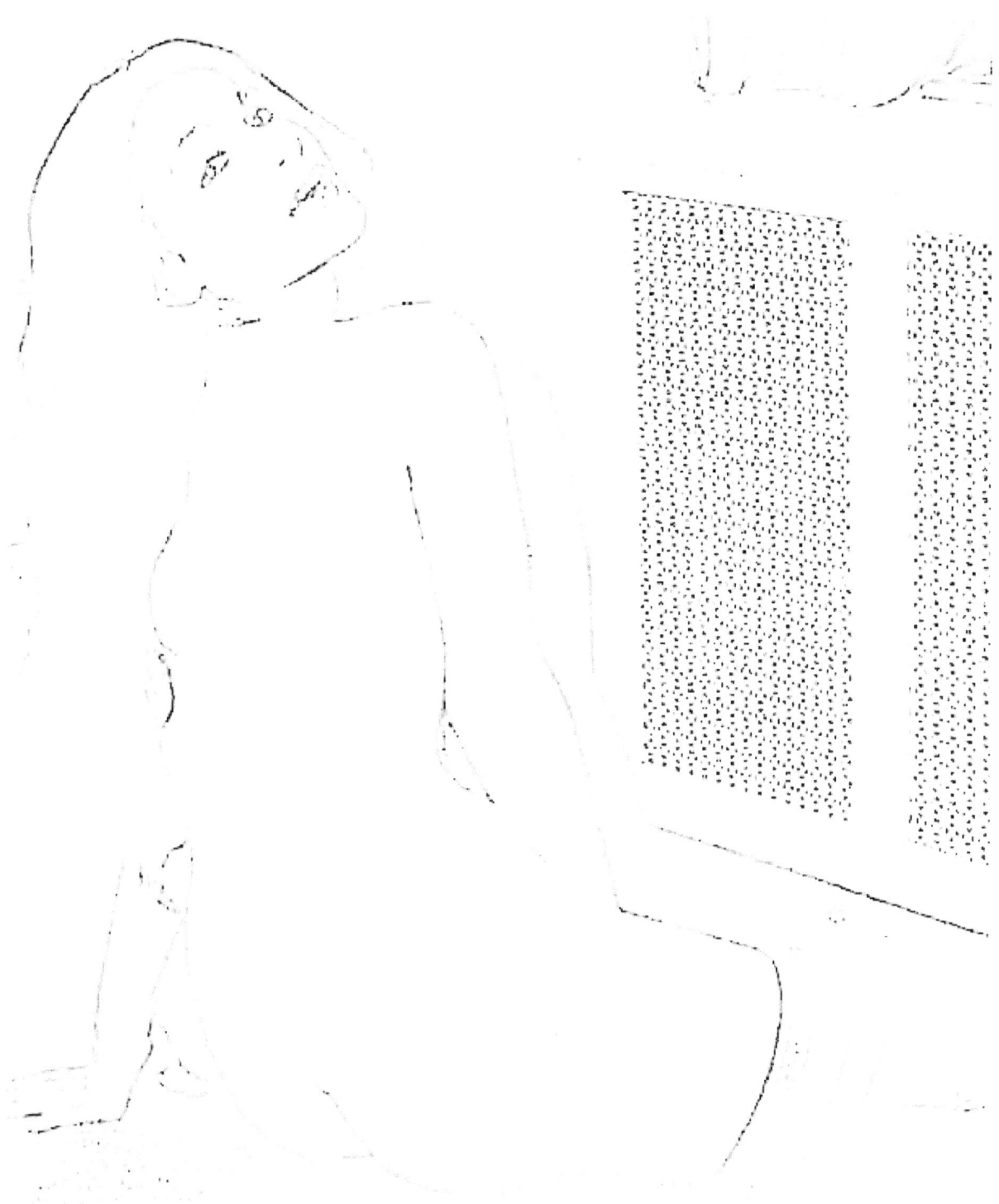

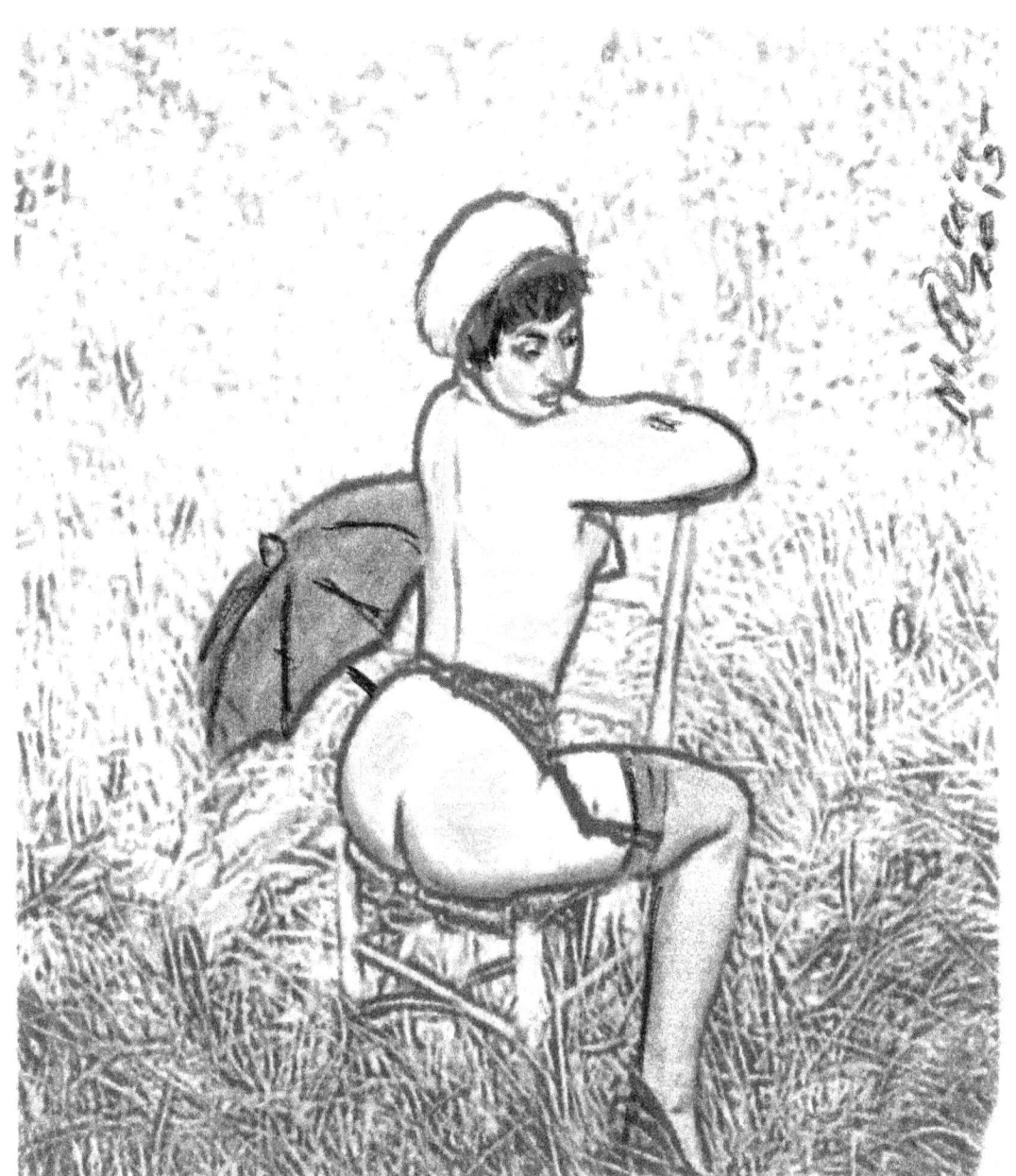

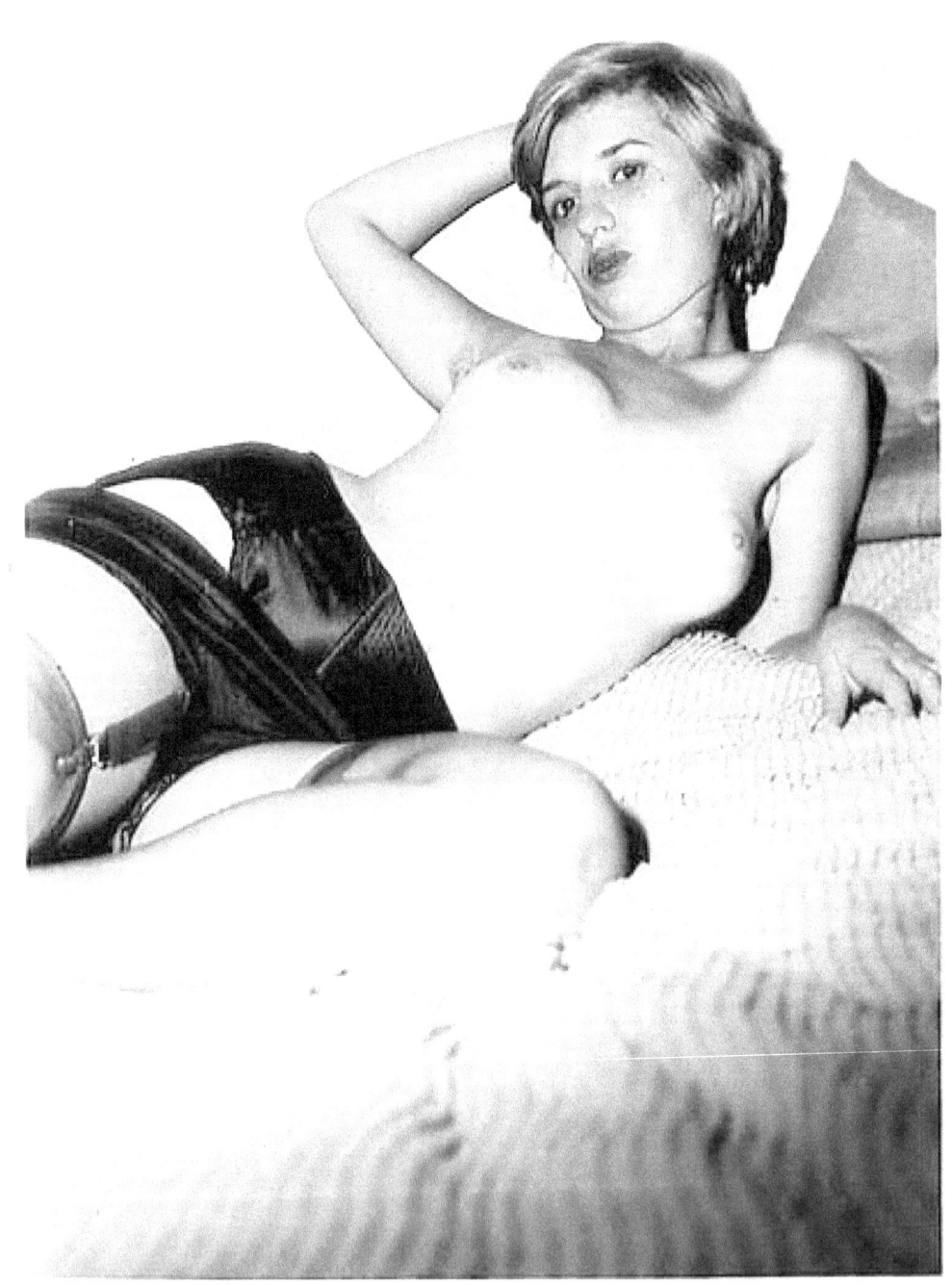

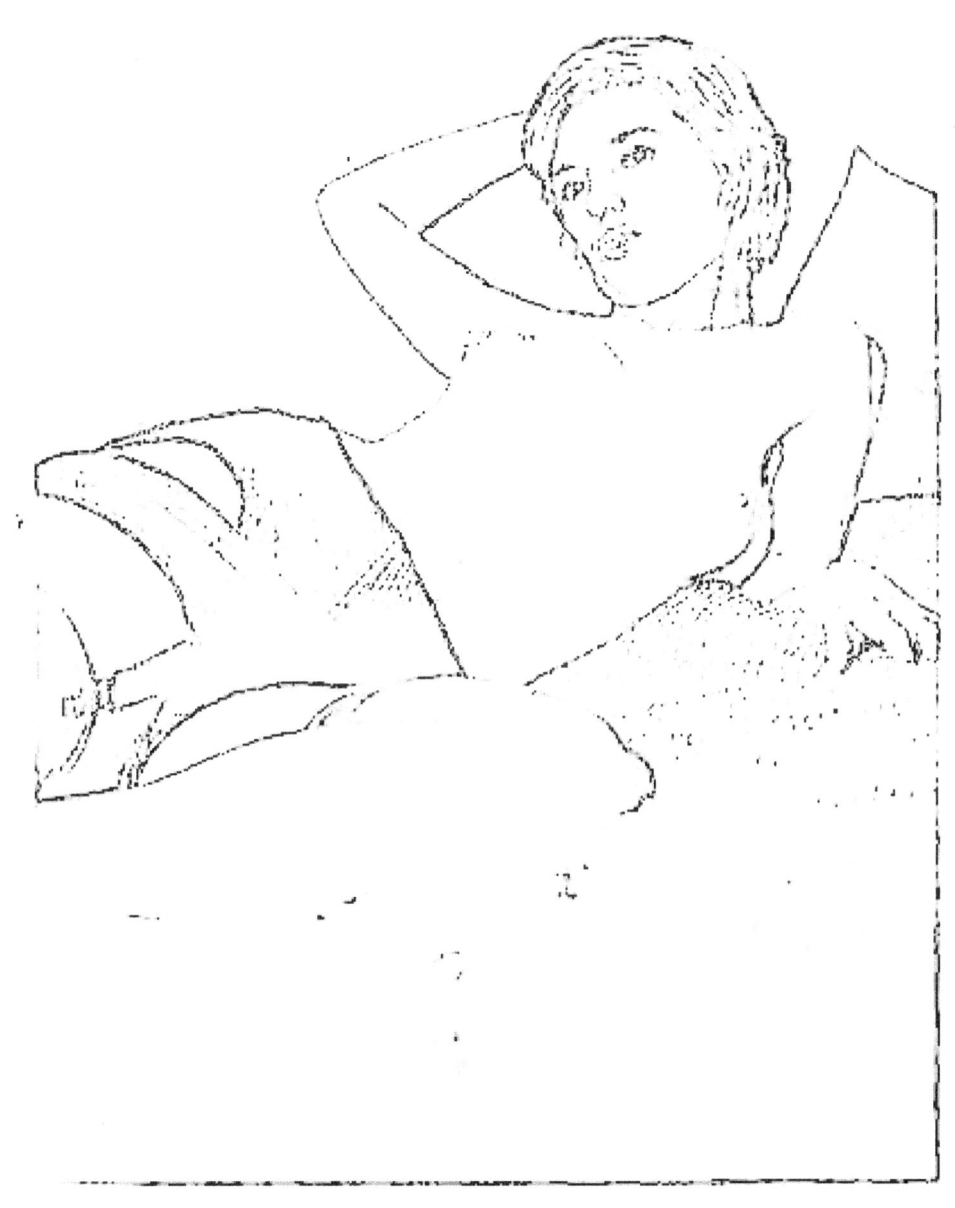

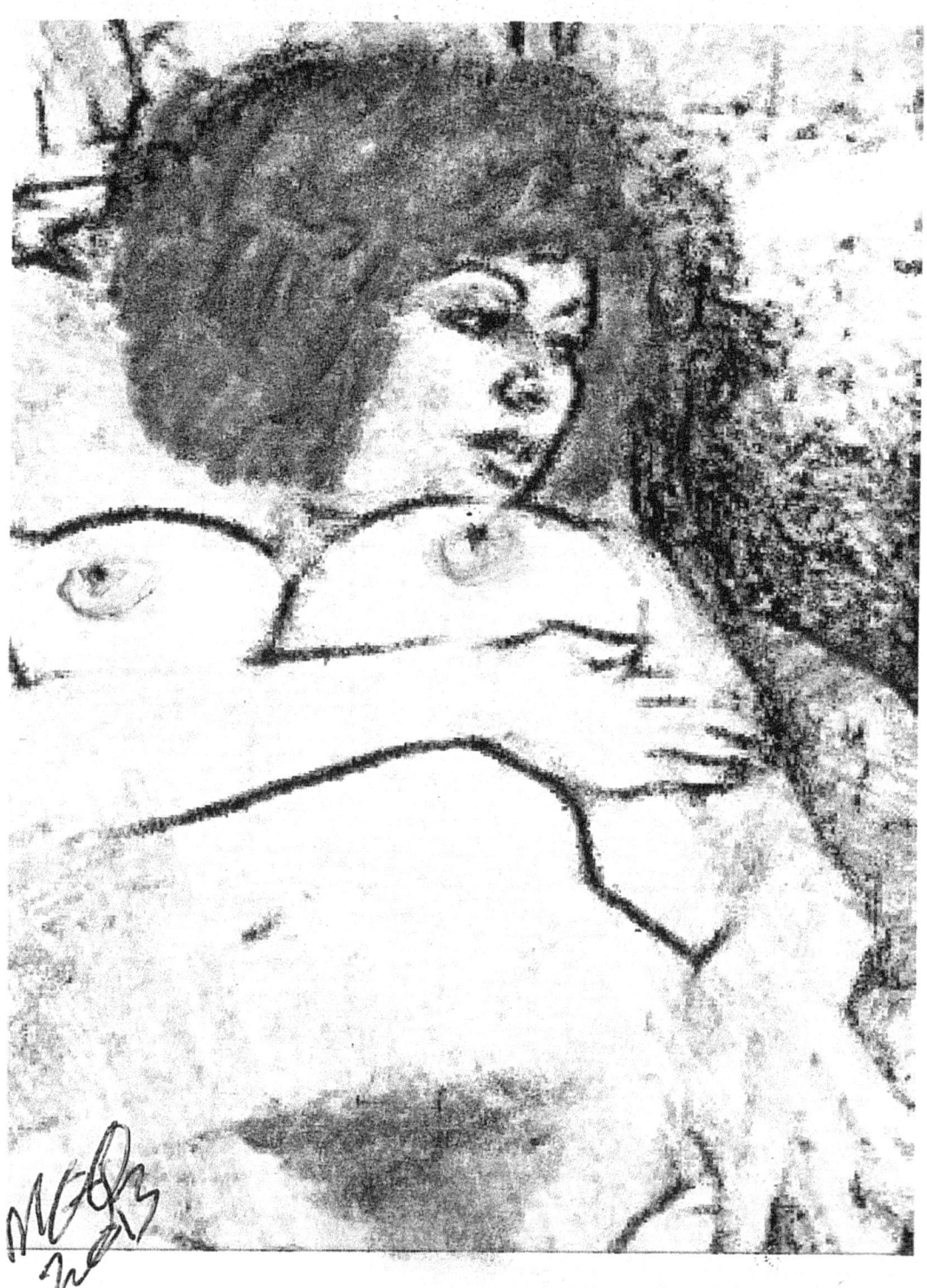

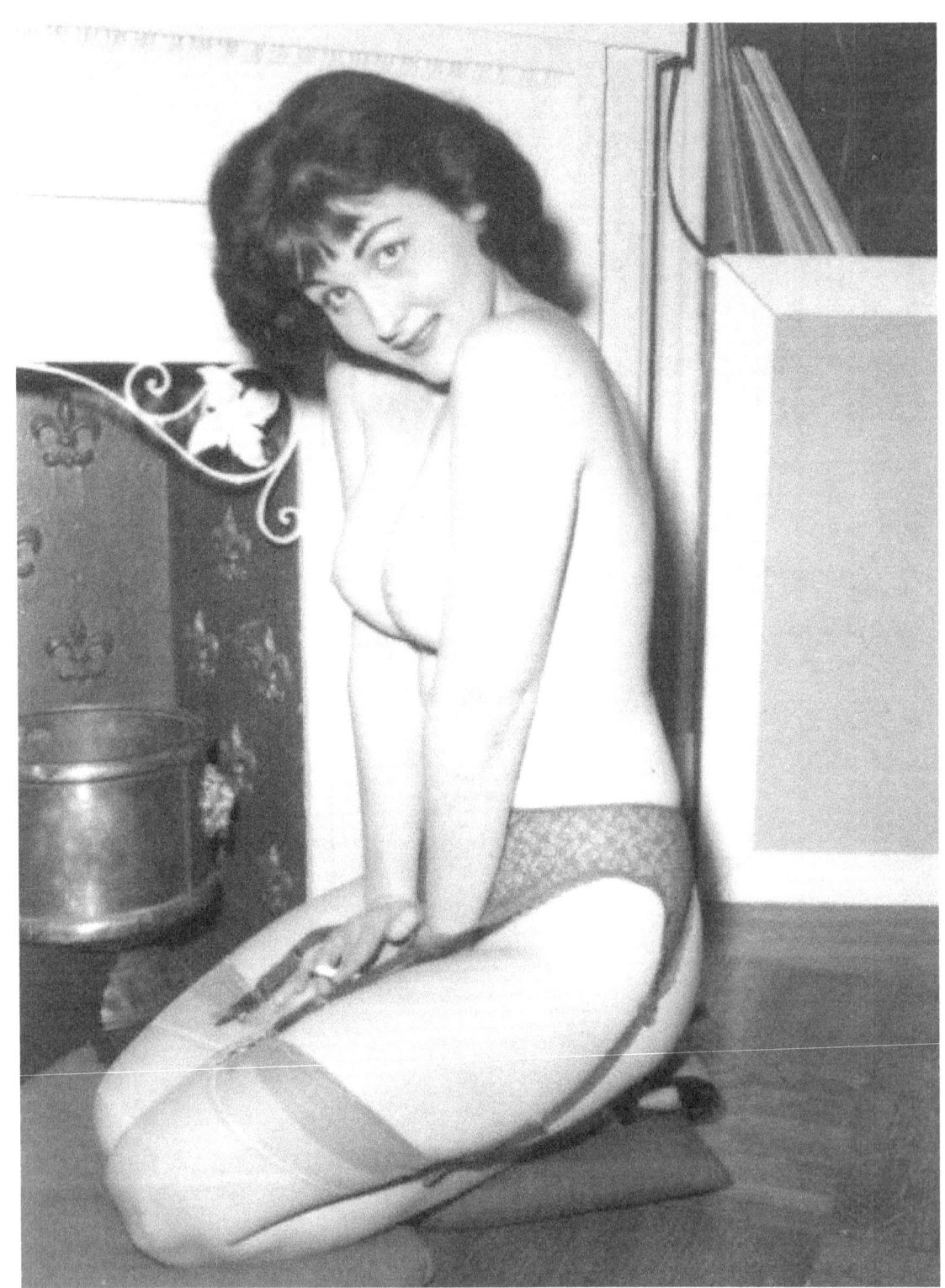

www.ingramcontent.com/pod-product-compliance
Lightning Source LLC
Chambersburg PA
CBHW080704190526
45169CB00006B/2240